Digital Photography Q&A

GREAT TIPS & HINTS FROM A TOP PRO

Paul Harcourt Davies

LARK BOOKS

Project Conceived and Edited by Sarah Hoggett, UK
Text Editors: Sarah Hoggett and Katie Hardwicke
Book Design and Layout: Paul Wood
Editorial Assistance: Delores Gosnell

Library of Congress Cataloging-in-Publication Data

Davies, Paul, 1950-
Digital photography Q & A : great tips & hints from a top pro / Paul
Harcourt Davies.-- 1st ed.
 p. cm.
Includes index.
ISBN 1-57990-663-X (pbk.)
1. Photography--Digital techniques--Miscellanea. I. Title. II. Title:
Digital photography Question and Answer.
TR267.D375 2006
775--dc22

 2005008143

10 9 8 7 6 5 4 3 2 1

DEDICATION
To my brother Peter—
one of the very best

First Edition

Published by Lark Books, A Division of
Sterling Publishing Co., Inc.
387 Park Avenue South, New York, N.Y. 10016

Text © 2006, Paul Harcourt Davies
Photography © 2006, Paul Harcourt Davies unless otherwise specified

Distributed in Canada by Sterling Publishing,
c/o Canadian Manda Group, 165 Dufferin Street
Toronto, Ontario, Canada M6K 3H6

Distributed in the U.K. by Guild of Master Craftsman Publications Ltd., Castle Place, 166 High Street,
Lewes, East Sussex, England BN7 1XU
Tel: (+ 44) 1273 477374, Fax: (+ 44) 1273 478606, e-mail: pubs@thegmcgroup.com,
Web: www.gmcpublications.com

Distributed in Australia by Capricorn Link (Australia) Pty Ltd.,
P.O. Box 704, Windsor, NSW 2756 Australia

If you have questions or comments about this book, please contact:
Lark Books, 67 Broadway, Asheville, NC 28801
(828) 253-0467

Manufactured in China

ISBN 1-57990-663-X

For information about custom editions, special sales, premium and corporate purchases, please
contact Sterling Special Sales Department at 800-805-5489 or specialsales@sterlingpub.com.

Contents

Foreword

After some careful research, you've finally bought a digital camera. Once home, you open the box and take out your beautiful new toy. After a while trying to make sense of the instruction book, you press the button and take a picture—and there it is on screen. You have started on a great new adventure into the world of digital photography.

With a digital camera, everything happens so quickly: there's no waiting to finish a film, no trip to the photo store, and no wait for the pictures. Better still, if the picture isn't what you expected, you can delete it and try again without wasting expensive film.

There's no doubt about it, a digital camera can open up a fascinating world of images—but it's not long before the questions start. How can I achieve this… ? What happens if…?, Is there any way I can ...? Your instruction manual rarely gives you the answers you need.

And that's precisely where this book comes in: by talking to both complete beginners and more experienced photographers who have just switched over from film to digital, I've put together simple answers to many of the most frequently asked questions. Part 1 will help you to understand how your digital camera actually records an image, and how you can make the most of your camera's controls. Part 2 answers all those questions about actually taking a picture, with tips on how to take better pictures. The final section tells you everything you need to know about transferring your pictures onto a computer, manipulating and improving them, printing them, and storing them. I hope it will take the mystique out of digital photography and that you will gain as much enjoyment from taking and showing your photos as I have.

PAUL HARCOURT DAVIES

The fun starts here!
With a digital camera there is no limit to the great pictures you can produce.

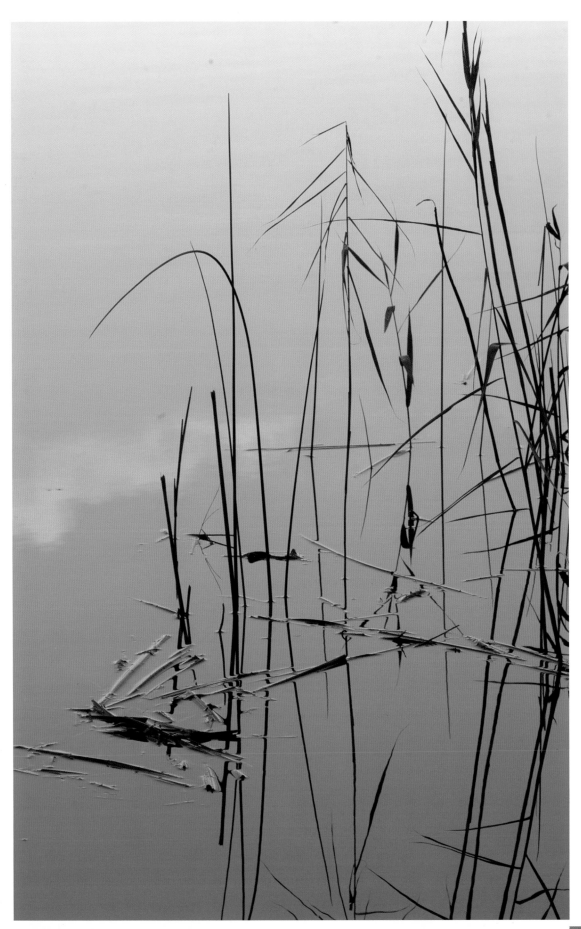

PART 1

Understanding your digital camera

If you're completely new to digital photography, or a little scared by new technology, it can all seem rather daunting to begin with: there's so much incomprehensible new jargon to get to grips with and features that you may never have encountered before, even if you've been using film-based cameras for years. This section takes you through all the different features that you're likely to come across on a digital camera and explains clearly and simply what they can do. If you've already bought a digital camera, it will help you to get the best out of it. If you're still trying to decide what features you really need, it will help you to make an informed choice about what to purchase.

All in one
A compact digital camera provides everything you need in one convenient package—perfect for vacations.

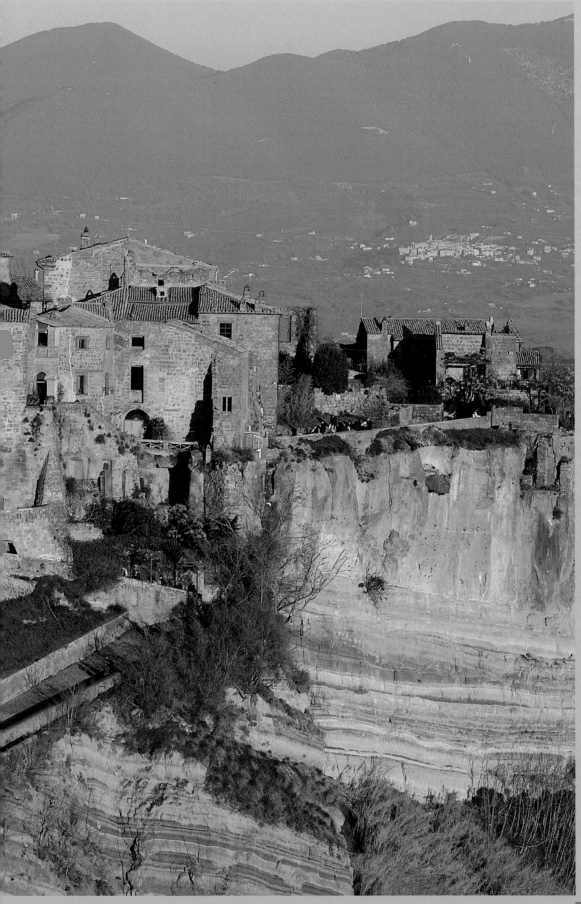

1 How does a digital camera record an image?

Holly berries
The sensor in a digital camera records three colors (red, green, and blue)—two of which are shown here. The human eye is particularly sensitive to greens and detects fine shades of color, so the sensor has twice as many green sites as either red or blue.

Cut down to their basics, both film and digital cameras are light-tight boxes. There is a lens at one end, which gathers the light and then focuses it on a sensitive surface at the other end, which reproduces the image. In the past, film provided the sensitive material. In a digital camera, the sensitive surface has thousands—even millions—of tiny cells printed on it in a regular pattern, known as a matrix. All cameras have some way of controlling the amount of light coming in, either through a hole (the iris) that can be set at different sizes (the aperture) or by exposing the sensor for a longer or shorter time—controlled by the shutter speed in film cameras.

On the sensor in a digital camera, each cell in the sensor array is a tiny exposure meter, which produces an electrical signal whose strength depends on the amount of light falling on it. This makes it sensitive to brightness. To introduce color sensitivity, each cell is covered with a red, green, or blue filter and thus responds to just one of the

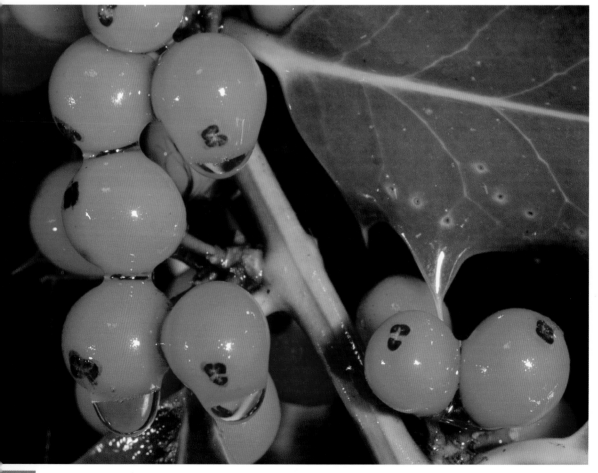

IIn a Bayer pattern, there are twice as many green-sensitive cells as either red or blue. Color-sensitive filters are positioned above the sensor array, allowing just one of the three primary colors through onto the sensor itself.

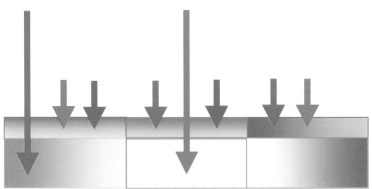

Ideally filters should pass only their own colors, but a degree of mixing is allowed for in the camera software.

primary colors. In most digital cameras, the cells are arranged in a pattern known as the Bayer pattern, which has two green-sensitive cells to every red or blue sensor (our eyes are most sensitive to green).

The electrical impulses from each cell are digitized and then processed by the camera to give a brightness and appropriate color that appears on screen as a "pixel." The pixels make up the image file and this is written into the camera's memory.

To get the clearest, most faithful color image on screen, the camera software takes information from neighboring pixels and processes that, too. This is known as interpolation (see Jargon Buster, at right). Things are not quite as simple as one sensor being equal to one pixel— although in better cameras the number of sensors and the number of pixels produced are roughly the same.

jargon buster

aperture—the hole in the lens through which the light passes, traditionally measured as a scale of F numbers. (The bigger the number, the smaller the aperture.)

exposure—getting the right amount of light onto the sensor. Exposure is controlled by the speed of the shutter and the size of the lens aperture.

interpolation—the clever guesswork performed by the camera software for creating extra pixels by taking the brightness and color values from adjacent sensor cells.

matrix—the geometric pattern in which all the cells making up the sensor are arranged.

pixel—the single block of information from which a digital image is made.

sensor array—the collection of light-sensitive cells that generates the pixel. The sensor array is sensitive to variations in color and brightness.

2 *What are pixels?*

f you look at any magazine picture with a magnifying glass, you will see a mosaic of tiny colored dots arranged in a pattern. These are the "building bricks" of the image, which our eyes merge into a picture. With a digital image the "bricks" are pixels—tiny colored squares that make a continuous picture when they are packed together. To see pixels in a digital picture just keep enlarging it on your computer screen and you will see each one has both color and brightness. Generally, the more pixels, the finer the detail recorded, and the higher the resolution (see Question 4, page 14).

Strictly speaking, pixels refer to the building blocks that make up a picture—but people often use the term when they mean the cells on a sensor, too. Each cell produces information for one pixel—but the final image is created by the camera software. When you buy a camera, look at how many "genuine pixels" it has—check the camera's specification in the manual. This is very close to the number of cells on the sensor. The much higher "interpolated value," where extra pixels are created by taking data from surrounding sensor cells, is usually what the advertisers concentrate on, because most people buying a digital camera assume that more is best: it is, as long as the pixels are "genuine" and not guesswork.

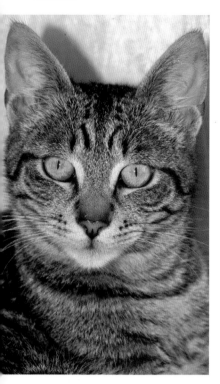

Pixels—image building building blocks (above and below)
To your eye the pixels that make up the image are smoothed out when there are enough of them (above)—but as you enlarge it (below), the image breaks up into blocks of color.

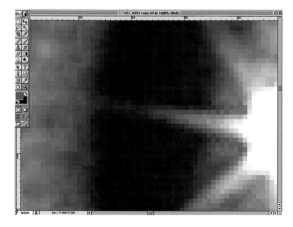

Leaves in fall (right)
The pixels change to create edges to leaves, details on faces, and so on. These are easier to see when there are dramatic changes in color.

How many megapixels do I need?

A pixel is a single block of color that makes up a digital picture. A megapixel is equivalent to one million of these blocks and is the maximum number of pixels captured by the camera's sensor. A decade or so ago, a camera sensor would produce 320 x 240 pixels (76,800 pixels) and an image that looked as if it was made of blocks. Now, even many basic cameras have 2–3.5MB— and the number is rising. In theory, more pixels means sharper pictures. Choose the biggest pixel count—but make sure they are genuine pixels.

Painted lady butterfly (above)
If you think you may want to make large prints, then set the highest resolution on your camera as this captures the fine detail you will need. For snapshots, use medium JPEG or even small JPEG.

The Cilento coast (below)
With most digital cameras you can change the resolution from one picture to the next, so you can have small and large files together on the same card—useful if you suddenly come across a dramatic landscape such as this.

To decide how many megapixels you need, think about how you are going to use the images. If you simply want to e-mail them to friends, then you will only need a camera with 1MB or less. However, a good general-purpose figure that will cover both e-mail and printing good quality, standard-sized prints is 3.5MB, available on good compact cameras. For very high resolution, large poster-sized prints, you will need 5MB or more.

Also bear in mind the RAM capacity of your computer, as large or high-resolution files take up a lot of memory. It is worth saving images on CD to store them.

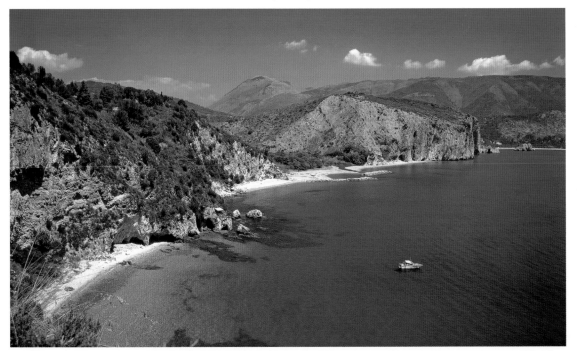

What does "resolution" mean?

Resolution is all about the detail you get in a picture and how good your camera is in revealing it. When you view a small image on your computer screen there is no obvious difference between a low-resolution picture and a high-resolution picture. The difference only becomes apparent when you magnify them. Magnify a low-resolution image on screen and detail quickly breaks up as you reach the colored blocks of the individual pixels. With high resolution, you can keep on going and reveal small details clearly as you enlarge the image more and more until you reach the individual pixels.

In digital photography, resolution is related to file size—the bigger the file, the more information it can contain and the more pixels it will generate on screen, so you capture more detail, resulting in a higher-resolution (sharper) image. See also Question 24, page 43.

Low-resolution image (above)
With a low-resolution image, the details break up when you enlarge and the print looks "grainy."

High-resolution image (below)
With a high-resolution image, you can keep enlarging without it breaking up into individual pixels.

5 What do acronyms like JPEG, TIFF, RAW, and GIF files mean? When and where are they used?

The different file formats have evolved because images need to be stored for different purposes. It takes a lot of memory to store data, so some formats "compress" the images in order to fit more pictures on a memory card.

The RAW mode is usually found only on digital SLRs and more expensive digital cameras. RAW files are not compressed. They take up a lot of space on your camera's memory card and on your computer's hard drive. You can convert them to either TIFFs or JPEGs to make prints.

JPEGs can display up to 16.7 million colors, the number needed for photo-realistic pictures. JPEGs use "lossy" compression, which means that data is lost every time you open and re-save a file. To get around this, copy your JPEGs onto a CD before you open them; that way, you can go back to the original image if anything goes wrong. You can set the camera to a number of different resolutions for JPEG.

TIFFs handle 16.7 million colors without data loss, but they take up a lot of memory. In practice you see little, if any, difference between large TIFF and JPEG files, but you will get six or seven times more JPEGS on a memory card.

GIFs are small files with 8-bit color (250 colors only). Compression is lossy. Shoot in GIF format if all you want to do is look at the image on screen.

PNG uses lossless compression and supports 24-bit color. It is ideal for putting your pictures on the web.

Baby Caia (above)
To get the most from your card and not compromise on quality, set it to shoot medium JPEG format.

Leopard (below)
Large JPEGS retain detail. You will see no difference between these and pictures shot in TIFF format.

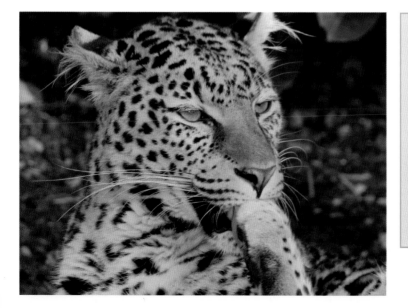

jargon buster

You'll probably never need to know what the abbreviations stand for, but here they are:
JPEG — Joint Photographic Expert Group
TIFF — Tagged Image File
RAW — a pure data file
GIF — Graphics Interchange Format
PNG — Portable Network Group

6 What are memory cards? And which ones can I use with my camera?

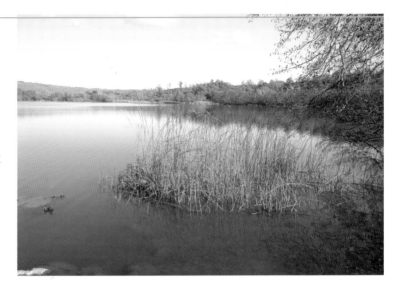

A memory card is simply a card or mini disk that you slot into the digital camera. Each image that you take is stored on it until the card is full—at which point you need to transfer the images to a computer of some sort. With any new technology, different manufacturers produce widely different ways of storing data. With digital cameras the main contenders (and the most widely employed) are Compact Flash (CF) and Smart cards, which simply store images as data. Sony has its own system of memory sticks that are extremely good but can only be used with Sony equipment.

Compact Flash cards are slightly larger than Smart cards and can provide much greater storage space. Smart cards are less expensive and great if you need lots of smaller images. You can change to a new card to give more storage space in seconds. The number of pictures you can store depends not just on the capacity of the card but on whether they are stored as JPEG, TIFF, or RAW files.

Be prepared!
Prices of memory cards have plummeted so make sure you always spares for every picture opportunity.

Salamis, North Cyprus
When you're going on vacation, you'll want to take lots of images—so make sure you have enough memory card capacity. Card prices are falling all the time and capacities are rising.

size of card	128 MB	256MB	512 MB
basic	142	284	568
JPEG norm	74	148	296
fine	37	74	148
TIFF	7	14	28
RAW	12	24	48

The table shows the average number of photos you can fit on a memory card on a 6MB digital SLR, using different file formats.

7 Why do I need a "film speed" (the ISO rating) with a digital camera?

Reeds at dawn
Dawn light has a cool feeling. Set the camera to, say, ISO 400 to avoid camera shake.

Evening light
To avoid noise (see page 33), keep the ISO rating low and use a tripod or rest the camera on a wall.

The ISO rating is a term used in film-based photography to denote the film's sensitivity to light: the higher the number, the less light you need to get the correct exposure. Even though no film is used in digital cameras, digital camera manufacturers adopted the same terminology because most people are familiar with the concept. They also used the same numbers as in film—64, 100, 200, 400, and so on.

On your digital camera, the numbers denote the reaction speed of the camera's sensors: you can make them more (or less) sensitive to light by altering the ISO controls. But unlike film, where you have to shoot the whole roll at the same setting, you can adjust the controls from one shot to the next, if required, to suit different lighting conditions.

In low-light conditions or to capture fast-moving action, set the ISO rating to a higher number (400 or more). On bright, sunny days or in snow, set a lower number (200 or less). If you want to be sure of capturing every bit of detail, use the lowest ISO speed. Many cameras default to 400. You can also adjust the lightness or darkness of the picture by using the camera's exposure compensation button (see Question 9, page 20).

8 **My camera has a number of different mode settings. What is the difference between them?**

Camera manufacturers try to make things easier for us. In automatic mode, the camera selects a combination of shutter speed and lens aperture that the designers think is the optimum for a particular situation. Many people use nothing but automatic mode and all the adjustments you need for landscapes, close-ups, portraits, groups, and even snow scenes are made for you.

As you get better at taking pictures, you may find that you want to make your own choices. If you don't want any help, set your camera to manual mode, if your camera has that setting. You then have to take an exposure reading and set the shutter speed and aperture (f-number) to the value you want (see Question 33, page 53). This is great if you are a keen photographer—but it's much easier to go automatic if you find the technical side a little complex.

The simplest modes to adjust are aperture priority and shutter priority. With aperture priority you set the aperture and the camera sets the shutter speed to give the correct exposure; a smaller aperture means that more of the image is in sharp focus, so this is useful for close-ups. With shutter priority you set the shutter speed and the camera adjusts the lens aperture—useful when you need a high shutter speed to freeze a fast-moving subject.

Wide-angle mode (below)
You can capture the greatest spread with the wide-angle mode—great for vistas and whole buildings. Landscape mode takes a narrower slice of the scene .

Telephoto mode (opposite)
To capture details —part of a building, for example—set the camera to tele (telephoto) mode and use the zoom, moving in or out to frame things and make a composition you like.

9 **My camera has a number of different metering modes. Which one should I use?**

All digital cameras have a light meter built into them that reads the light level in a scene and assesses the combination of shutter speed and aperture required to get the "right" result. Provided nothing is very light or very dark, the camera meters work well.

Problems can arise either when there are highlights from bright lights, reflections, or the sun in a scene or when there are very dark areas. In situations such as these, the meter is fooled. If you include too much bright snow in the scene, for example, the meter thinks the whole scene is bright; consequently, it tries to underexpose, and the result is too dark. Conversely, take a photograph in a shady wood and the camera tries to overexpose because this time there is not enough light.

Designers have been clever in thinking of ways around this and giving us metering "modes" where the sensor in

Photographing snow
Snow can be tricky whatever mode you set. Let the camera act on auto, look at the result on your LCD screen, and then either lighten or darken the shot using the plus and minus on the exposure compensation button.

the camera does not look at the whole scene. The different modes are describe in the Jargon Buster box, at right.

But, best of all, with a digital camera you can look at the LCD screen and see if the result is too light or too dark. Take the picture again using the exposure compensation button: if it is too dark on screen, increase the exposure (go to the + side); if it is too light, underexpose (move to the – side).

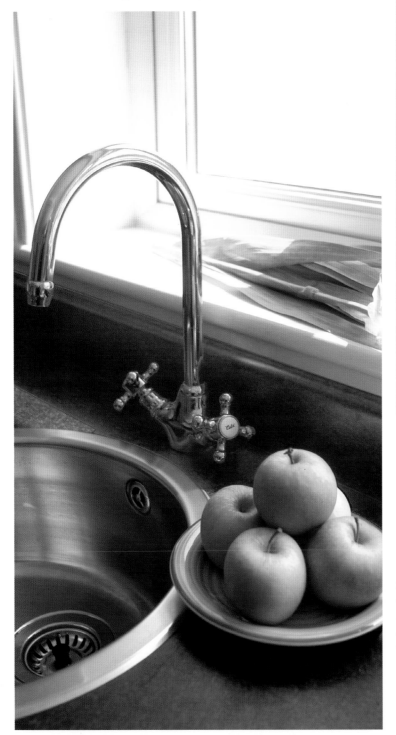

jargon buster

center-weighted mode— means the meter sensor takes most of the reading from the center of a scene.

spot metering mode—takes a reading from a small area: you choose the part that is a midtone, take an exposure, and use "exposure lock" to use this value for the whole scene. With practice, this is very accurate.

matrix metering mode— this is much harder to fool and is the most reliable mode in 99percent of situations. The viewfinder is divided into different segments and the meter takes a reading from each one (the more segments it has, the less likely it is to be fooled). The readings are compared with combinations programmed into the camera's memory. The camera gives a compromise and very few things fool it—apart from possibly bright snow scenes or the proverbial black cat in a coal cellar.

Scenes with bright highlights
With highly reflective surfaces, you get very bright areas in a picture. Sometimes these fool the camera into believing that the whole scene is very bright; it tries to make everything darker and the result is too dark. Just look at the image in the the LCD and take it again, over- or underexposing until it looks right.

10 My camera has a wide-angle and telephoto setting. What do these do?

Most digital SLRs and medium-format cameras have interchangeable lenses, allowing you to alter how much you can fit into the frame without changing your position. Compact digital cameras have only one fixed lens—but all but the most basic cameras have settings that you can change to create the effect of interchangeable lenses. A wide-angle setting captures an expanse of a scene and is great for landscapes, while a telephoto setting lets you close in on details. People moving from film to digital may have come across the idea of an "angle of view" (see diagram, below).

Zoom lenses give the best of all worlds, for you can stay in the same position and alter the framing until the image is

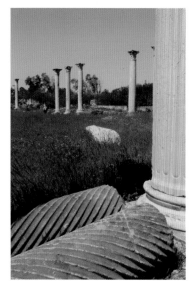

Greek columns (above)
For effective wide-angle shots, include something in the foreground, such as these fallen columns, to lead the viewer's eye into the shot.

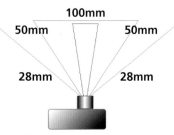

Angle of view
The diagram above shows the coverage that you will get from the same postion using lenses of different lengths.

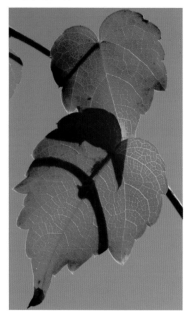

Backlit leaves (above)
Telephoto settings and lenses are essential for picking out details such as these leaves. Keep your subject large in the frame for extra impact.

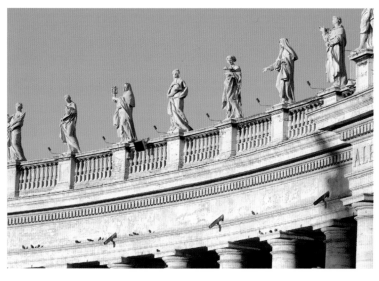

St Peters, Rome (above)
Although this shot looks as if it was taken on a wide-angle setting, it was taken from some distance away using the telephoto setting—useful when you cannot get closer.

to your satisfaction. For digital zoom compact cameras, check the camera's specifications so that you are familiar with the different angles of view that the lens can give you—and experiment to see the effect for yourself.

Some cameras create the effect of wide angle or telephoto digitally (the so-called digital zoom, see Question 11, below) by taking more or less pixels in an image and filling the screen. However, the image may not be true due to the effects of interpolation (see Question 1, page 10).

top tip

Include a foreground subject in a wide-angle view to give a sense of scale and point of interest and prevent everything from looking too small.

11 What is the difference between an optical zoom and a digital zoom?

If you've had a film camera with a zoom lens, then you will have come across the "optical zoom," which operates by moving lens elements inside the body tube to move from a wide-angle to a telephoto view. A digital zoom is just a fixed lens; the camera's electronics take a look at a smaller slice of the image to give a telephoto view and at a larger section for a wide-angle view. When you do this, you capture less detail and so lose quality—particularly if you then make a big print of the image.

Religious parade (above)
Optical zooms capture the maximum detail and work perfectly, provided your subject is not too far away.

Golden oriole (right)
Here, the optical zoom was used to get close to the bird and create an image that is not too "grainy."

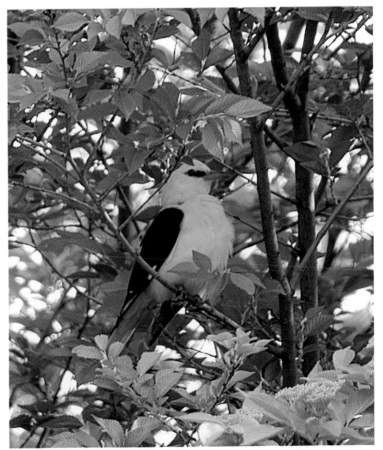

12 What do you use the different lenses for—and how do I compare focal length of digital and film lenses?

Most of us who use a zoom lens never bother to look at the figures engraved on the lens—and on a compact camera there often aren't any. But if you have come into the digital world from film photography you have to change your ideas slightly—unless you have a top-of-the-range "full frame" SLR, where the sensor size is the same as the traditional 35mm film area.

With 35mm film cameras you can recognize a lens from its focal length. For instance, a "standard" lens has a 50mm focal length and gives approximately the same coverage as the human vision. Wide-angle lenses range from 35mm through even shorter lengths such as 28mm, 24mm and 20mm, which become progressively wider. At the other end of the scale a modest telephoto, such as 100mm, is great for portraits, whereas for distant objects 200mm and greater is needed. If you use these lenses on a digital SLR the effect is not quite the same (see Question 13, page 26) and you will need to make adjustments to compensate. The table below shows equivalent focal lengths on different types of camera.

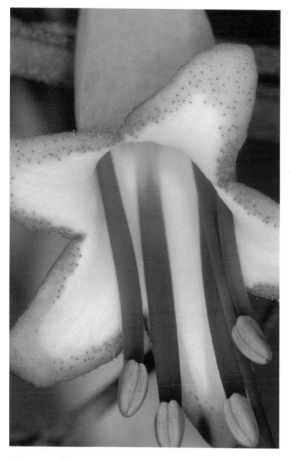

Flower close-up (above)
Many macro lenses for film cameras give life-size magnification. On a digital SLR you typically get x1.5 magnification with the same lens at the same distance.

	Actual Lens Focal Length								
35mm film camera w/ lens	20mm	24mm	28mm	35mm	50mm	80mm	105mm	200mm	300mm
Approx. lens focal length needed on most digital cameras to get the same view as above	13mm	16mm	19mm	23mm	33mm	53mm	70mm	133mm	200mm
Approx. equivalent view (in 35mm film format) that the lens (top line) would give if mounted on most of today's digital SLRs	30mm	36mm	42mm	53mm	75mm	120mm	158mm	300mm	450mm

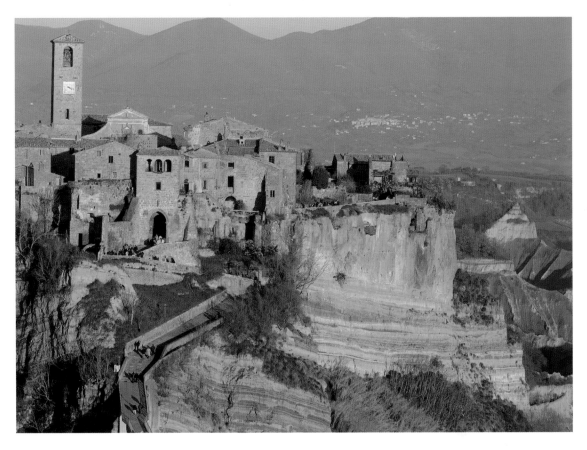

Bagnoregio, Italy (top and right)

Do you want to take a part of a view (right) or move back and set it in a landscape (above)? Do both: use the zoom and get two completely different pictures.

Thistle (below)

Zooming from wide angle to telephoto lets you close in on your subject.

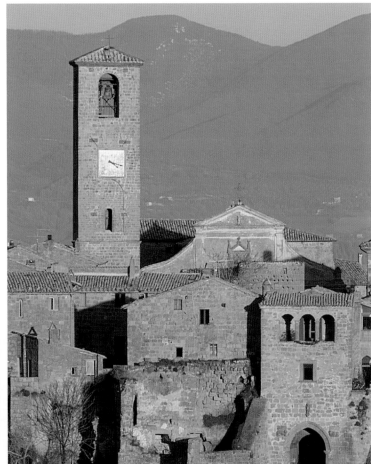

13 Can I use my 35mm film-camera lenses on my new digital SLR body?

Many people buy a digital SLR body as a way of upgrading a system after having invested in a collection of lenses for a film-based system. Some manufacturers are better than others in allowing "backwards compatibility;" others introduce new functions and new lens mounts. You can often use older lenses in "manual" mode—but this usually means no exposure metering and everything has to be set by hand. It is possible to attach your film-camera lense—but beware of the differences in magnification and use them to your advantage where possible.

The sensor array in a digital camera is often smaller than a frame of film and the captured image is enlarged electronically. The lenses therefore have different focal lengths on film and digital (see table on page 24). This effect is often described by a magnification factor, or camera factor. For example, a camera with a factor of 1.5 converts a 24mm film-camera lens into a 36mm digital lens (reducing coverage). For a landscape photographer, to get the equivalent of a 24mm lens you would need to use a 16mm optic. However, since the digital camera uses the central part of the image, designers have produced a marvellous new generation of unheard-of add-on wide-angle lenses, because they do not have to worry about correcting curvature of lines at the edge of the frame. If you are a landscape photographer, you might have to budget for buying one of the new wide-angle digital zooms plus a digital body.

For photographers using long telephotos, the effect of magnification factor is to their advantage. A 200mm lens, for example, becomes, in effect, a 300mm lens with the same maximum aperture. This is great for wildlife photographers where macro lenses take you to higher magnifications and telephoto lenses get you much closer to your quarry.

Hot springs (above)
On many digital SLRs, focal lengths change because the sensor array is smaller than a film frame. Here a 18mm wide-angle lens was needed to give the same coverage as a 24mm film lens.

Sunflowers (opposite)
This shot was taken on a 15–30mm digital zoom. To get the equivalent coverage on a 35mm film camera, you would need a 22–45 mm wide-angle zoom.

14 My digital camera has several flash modes. What's the difference between them?

Close-up subjects (above)
On-camera flash gives good coverage with close-ups and lights up subjects in shade.

Dull days (above)
Flash in auto mode adds "punch" to shots on a dull day. The camera controls exposure.

Across the generations (right)
Slow synch flash lets background light into your picture as well, producing a more natural result.

Many cameras come complete with a built-in flash unit—but there is very limited control, so the lighting is not always as subtle as you might like. Various flash modes are offered on some cameras:

Red-eye-reduction produces a brief flash before the main flash. This has the effect of making the pupils in the eyes of your subjects smaller (provided they are looking at the camera). When the main pulse of flash comes, not so much is reflected back from the blood vessels in the retina at the back of the eye.

Slow synch makes the exposure for ambient light (daylight or artificial light) long enough to be recorded, thus avoiding the dark areas in the background that you get with a small flash alone.

The metering system for on-camera flash often only works over a small range of apertures and distances. If you use it for close-ups, you will get overexposure at wide apertures. Use f/8, f/11, or smaller to prevent this. If your shots are too dark, use a wider aperture; if they are too light, stop down and use the LCD as a visual exposure meter, changing settings using the exposure compensation mode until it looks just right.

15 The built-in flash on the camera seems very small. Can I use a separate flash?

Illuminating the background (above)
If the background is close to your main subject, a built-in flash will be powerful enough to illuminate it.

Small groups (below right)
A built-in flash gives good coverage with small groups. With subjects further away, it is not powerful enough.

jargon buster

red-eye reduction—getting rid of red-eye reflection from the back of the retina by using a pre-flash.
slow synch—the shutter stays open to capture background light after the brief pulse of light from the flash.
overexposure—too much light reaches the sensor for the correct exposure (result: too bright and washed out).
underexposure—there is not enough light to give the correct exposure (result: too dark).

Your camera's built-in flash can work wonders for small-sized rooms and for lighting up people not too far away—but don't expect it to be able to light the interior of a huge building or a background in a distant group shot. (For this you will need to use slow synch—see Question 14.) If you want to use a separate flash, buy a camera that allows auto (where the camera measures the necessary flash exposure) and has an on/off switch for the flash.

Many digital cameras come with a "hot shoe" that lets you connect a flash gun and use it in manual mode. With more sophisticated SLR cameras you can buy a dedicated flash that is controlled by the camera's through-the-lens (TTL) metering system. Digital cameras use a different system from their film counterparts, rendering many TTL flash guns designed for film cameras unusable other than in manual mode.

The manual option is all you will need, for your digital camera then becomes the exposure meter. First, connect the flash using a flash lead or use a slave unit that fires the off-camera flash when the flash goes off. Take a picture and see what happens. If it's too bright or washed out on the LCD, make the aperture smaller to reduce exposure; if the screen image is too dark, open up the lens aperture. Make a note of what settings work the first few times and then you can get the right result in one or two shots.

16 Is there any point in using a tripod with a digital camera? If so, how do I use it?

Leaf veins
When you are shooting close-ups of leaves or flowers in the open air, not only does the increased magnification make any camea shake more apparent but the breeze can move your subject. Mount the camera on a tripod and, if possible, erect a wind shield around your subject, to minimize the risk of getting a blurred image. Take the exposure using the self timer, as your hands on the shutter button can set up vibration.

Tripods are used to prevent shooting blurred images when either you or your subject moves as you take a picture. If the shutter speed is fast enough, then slight movement makes no difference. You could try increasing the ISO speed to allow you to use higher shutter speeds, but this makes "digital noise" (see Question 19) more likely. A tripod is the ideal solution when you want detailed pictures, such as inside shots, where light levels are low.

In the base of most cameras there is a screw thread that lets you screw in a tripod head. If you are going to use a tripod regularly, then attach a "quick mount" that lets you connect and disconnect quickly. Remember, a rigid tripod is heavy and something extra to carry, but avoid cheaper, lightweight versions that may topple over.

However, with a little ingenuity, you can find other ways of supporting the camera. Brace your elbows (or the camera itself) against available walls, columns, and chair backs in a kneeling or prone position. If you want to get a low viewpoint for impact, then you can use your body as a tripod. Alternatively, cradling a soft camera bag between your knees produces a support that absorbs vibration. A good buy if you use a telephoto lens or setting is a small bean bag. It molds itself around the camera and gives a surprisingly sturdy support.

Blurring from camera shake
In low light conditions you are forced to use longer shutter speeds—so any camera shake creates blur.

Reducing blurring
A tripod will reduce blurring due to camera shake. Supporting a camera on a table or against a wall is a useful alternative to a tripod.

17 What does the white balance control do?

The white balance control makes sure that white objects in your photos come out looking white. Different light sources have different color temperatures; this means that objects that are illuminated by them have a slight color cast. Household light bulbs, for example, have a greater proportion of red and yellow than sunlight, so photos taken indoors often have a red or yellow tinge to them, while fluorescent lamps give a greenish cast.

With film-based cameras you need to change the film or use filters to suit the light source. With a digital camera, you can alter the white balance control. Many people set the white balance to automatic, which works reasonably well even when scenes contain several different light sources. Most digital cameras also have different settings for bright sun, cloud, shade, incandescent lights, fluorescent lights, and tungsten lighting. The program in the camera adjusts the levels of blue and red depending on which light source you have set.

You can "customize" the white balance setting by setting the menu to "white balance customize" and pointing the camera at a gray card—the standard used in photography that reflects 18% of the light. The camera registers the shot you take as its default until you change it.

Auto white balance setting
Most cameras provide a pretty good assessment of the "color temperature" of the light, electronically tweaking the red and blue responses of the camera sensor to get the right balance.

Shade setting
If you like your shots to have a warm feel, then adjust the white balance to shade, even in bright sunlight. This produces a slightly later afternoon feel when the sun is lower in the sky.

top tip

If you like your pictures to have a "warm" feel, you might find the "cloudy" setting works better than "auto."

Incandescent setting
Incandescent lamps with a hot filament produce more red and yellow than sunlight—but if you set the white balance outdoors to incandescent, the greater amount of blue gives a strange, cold feel.

Fluorescent setting
With the white balance set to fluorescent, a digital camera cuts down the extra green by adding magenta.

18 I used to use filters on my film camera. Can I use them with a digital SLR?

Many film-camera photographers make limited use of filters—often just for tasks such as giving a warm feel to colors on dull days (warm-up filters), accentuating blue skies or cutting reflections (polarizing filter), and reducing contrast between the brightness of the sky and the ground (graduated filters). It is possible to use these filters with a digital camera, but it is much simpler to adjust the white balance (see Question 17, page 31).

Morning and evening light has more yellow in it and so appears warmer, whereas the harsh light of a sun high in the sky is bluer. The white balance setting electronically adjusts the proportion of blue to red so that you can take pictures at different times of day and on cloudy or dull days, in the shade, even under street lights, and get the colors looking as you remember them. Fluorescent lights can give a greenish cast—but if you adjust the white balance, this disappears.

Effects filters that create starbursts, tobacco-colored sunsets, and a host of other things in film cameras can be bettered with digital technology and the inexhaustible supply of tricks and effects that you can apply to your pictures when they are in your computer.

Warming up colors (above)
The use of a warm-up filter (which is slightly orange in color) makes things look as if they are taken in late afternoon or evening. Setting your digital camera's white balance to shade creates the same effect.

Deepening blue skies (below)
A polarizing filter is great for deepening blue skies—but it is hard to use unless you have an SLR, since you can't see the result.

19 I've read about digital "noise" in magazines—what does this mean?

Fireworks
In low light, when the shutter is open for several seconds, you may get noise—but with a multicolored subject such as fireworks it will probably not be noticeable.

The background hiss that you hear if you've ever turned up the volume on a sound system when there is no CD playing is called "noise" and it comes from random movements of tiny electric charges in the electronic circuitry. In a digital camera, noise creates pixels of various colors that are not related to the image.

The effect is more obvious in cheaper cameras, but even some top-of-the-range SLRs have been criticized for the "noise" they create. It is most obvious when you increase the ISO rating, making the camera more sensitive when light is low.

Think of the information that makes up your picture as being in two parts—the information that you want from the scene and random contributions from inside the camera. When the camera operates at a low ISO rating, the proportion of noise to information from the scene is tiny—but the more sensitve the camera, the higher the proportion of noise.

When you magnify images to get big enlargements this noise becomes more obvious and you see odd colors and artefacts—additional information generated by the camera that bears no relation to the image. When you try to sharpen using a filter such as USM (Unsharp Mask) in your imaging program, it makes the noise more apparent, too.

20 My digital camera seems to use up alkaline batteries very quickly. Is there any way I can reduce consumption?

Digital cameras are classed as high-drain devices—the batteries have to power the internal computer, zoom, and even the flash, if you have one. Some alkaline batteries suggest they are high drain, but they don't last long.

In the long run you might be best served by buying a couple of sets of rechargeable NiCad (nickel cadmium) cells and keeping a spare set fully charged in your camera bag. They don't gradually run out but keep the same voltage and then "die." Unlike alkaline batteries, NiCad batteries can be recharged—but it's best not to recharge them until they have completely run down, since the cells have what is called a "memory" and will not recharge fully the next time unless they are drained.

NiMH (nickel metal hydride) batteries are slightly more expensive (look around and you will find them discounted) and don't have the memory problem.

Some cameras only run on highly expensive lithium batteries. If you want to take a lot of pictures, then make sure you choose a model that gives you the rechargeable option, too. It's better for your pocket and for the environment.

top tips

To conserve energy, try to avoid switching the camera on to look at images. Download them and view them on the computer instead.

If you can use the camera without the flash, then do so—an internal flash drains batteries veryquicky.

Flash drains batteries (left)
The drawback of digital cameras is their dependence on battery power. Flash was used to take this shot, which drains batteries rapidly, so always keep a spare set fully charged.

Cold conditions (right)
In cold conditions—on a winter skiing vacation, for example—your batteries may run down quicker than normal. Keep the camera warm in a bag or pocket when it is not in use.

21 What's the difference between a compact digital camera and an SLR digital camera?

"Grab" shots
From taking photos of your kids or friends on the spur of the moment, a digital compact camera is much less trouble than an SLR as everything you need is there in a single package.

Precise framing (opposite)
With a digital SLR, what you see through the lens is exactly what you will get in the picture, which is just what you need when you want to frame a shot very precisely. Digital SLRs tend be 6MB and more, giving the large files that are essential for serious work.

Compact cameras, as their name suggests, are all-singing, all-dancing cameras in a single "compact" package. They have a fixed lens and you treat them as a complete system—nothing added. They are great and even professional photographers use them. But when you want to cover every eventuality, then you need a camera that is part of a system—and the way you get that versatility is by using an SLR.

The initials are short for Single Lens Reflex, where what you see through the lens is exactly what you are taking. In other cameras the viewfinder and lens are separate and create something called parallax, because you are not seeing quite what you are taking. When you look through the viewfinder, you might think someone's head is in the picture—but only part of it is actually seen by the lens. The SLR has a prism on top and a mirror that flips up just before the shutter opens to take the picture—this acts as a sort of periscope to let you see and focus through the lens. SLRs also have interchangeable lenses, so you can fit everything from an extreme wide-angle to a long telephoto. They offer versatility and the ability to progress with a camera system as your needs change or your demands increase.

Cleverly designed single-unit cameras, such as those from Nikon (Coolpix) and Olympus, give you all the advantages of an SLR in a single unit and are a better buy for many people than the more expensive SLR. If you have already bought a film-based system such as Canon or Nikon, your best option might be to invest in a digital SLR body and use your existing gadgetry. For a true SLR, check that the camera has an optical viewfinder that works through the lens.

The table below summarizes the most suitable applications for digital compact and digital SLR cameras.

	point and shoot	holiday snaps	landscapes	portraits	wildlife	sport and action	professional and publishing
Compact	***	***	*	**	*	*	
SLR		*	***	***	***	***	***

22 I am thinking of upgrading to a digital SLR. Is it very different to a film SLR?

The look and feel of a digital SLR is very similar to a film SLR—but inside, instead of all the space taken up with a motor drive and film-transport mechanism, the digital SLR carries its sensor and associated electronics.

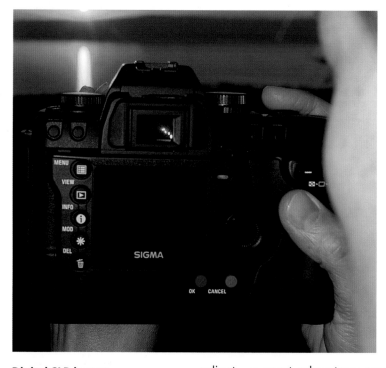

What will feel a bit overwhelming at first is just what you can do—all the things you have control over through a system of menus. On the back of all digital SLRs is a multi-function switch and a series of buttons where you can access images, adjust screen and camera settings, ISO setting, resolution, white balance, and so on. The images are available immediately to review and adjust—a great advantage over a film camera. And, of course, another advantage of a digital SLR is that there is no need to change film or add filters when you are working under different lighting conditions.

Many cameras also allow you to make color or contrast adjustments. In practice you can do this at a later stage in the computer; when you change settings on the camera, it is all too easy to forget that you've done so and leave them on the wrong setting. If you used filters on a film camera to cope with different types of light and times of day, then a digital SLR lets you do this through the white balance control.

Digital SLR layout
The general layout and feel of a digital SLR and a film camera are the same, since the design is well established. You may have to get used to a slight delay which gives a "soft" feel to the shutter. In many cases a digital body just adds to an existing system.

The immediacy of digital
A digital SLR is perfect for close-ups such as this, as you can frame your shot accurately. You can also see what you've shot immediately, and re-shoot if the focusing isn't quite right or the subject moved during the exposure.

PART 2

Taking digital photos

If you're completely new to digital photography, or a little scared by new technology, it can all seem rather daunting to begin with: there's so much incomprehensible new jargon to get to grips with and features that you may never have encountered before, even if you've been using film-based cameras for years. This section takes you through all the different features that you're likely to come across on a digital camera and explains clearly and simply what they can do. If you've already bought a digital camera, it will help you to get the best out of it. If you're still trying to decide what features you really need, it will help you to make an informed choice about what to purchase.

The seeing eye
Even with a point-and-shoot camera, you can create dramatic pictures simply by choosing your viewpoint carefully and using natural features, such as a rock arch or tree, to frame your shot. Good digital photography relies as much on your ability to see the potential of a scene as on your technical skill.

23 Should I use the LCD or the viewfinder for checking images?

Berries
An LCD is great for a checking the composition and for assessing the overall exposure before you take the shot.

Shooting in sunshine
When you are shooting in bright sunlight as in this scene of ancient Greek ruins, it can be difficult to see an LCD screen. Your local photo store will have accessory hoods that create shade and improve visibility.

The viewfinder and the LCD are suited to different situations. Most LCD screens don't show up fine detail, even with a magnifier. As you zoom in, you just get bigger pixels and the image breaks up—so they are not great for focusing. But they let you see how your picture will look, so you can choose whether to keep it or reject it and try again.

The viewfinder provides a clear image of what you are taking and works even when bright lights might make the LCD screen hard to see. In basic cameras, the viewfinder and lens are separate from one another; this doesn't matter until you try and take close-ups, when what you see in the viewfinder and what you get as an image differ slightly—an effect known as parallax. With more expensive cameras such as SLRs, what you see in the viewfinder is exactly what you will take through the lens.

Where the LCD really scores is when you take a photo by holding the camera above your head in a crowd, as you can still see the image you're taking—impossible with a viewfinder.

In short, use the LCD to review images once you've taken them and the viewfinder to focus and compose before you take a shot.

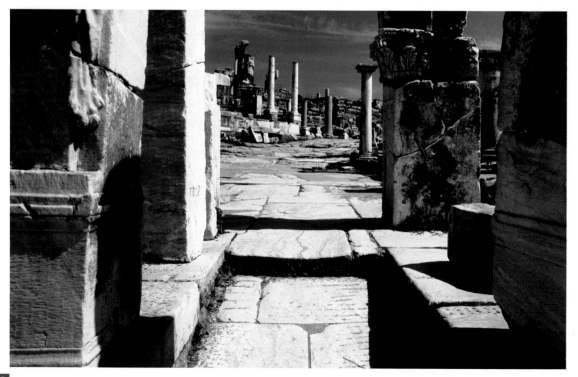

24 What resolution should I set on the camera—and can I change it from picture to picture?

The resolution relates to file size—and bigger file sizes mean more detail. If you are going to produce large prints, then you need to use the largest file size your camera offers (or the high-resolution setting). You can always reduce file sizes later to make smaller prints. Lower-resolution files are great for small prints, e-mailing to friends, or for putting on to the web because they transfer quickly; select a Standard setting from the Picture Resolution menu. See the table below for a summary of how many pictures you can take on a camera card at different resolutions.

With a digital camera, you can change the resolution for each picture you take—impossible with film! So if you see something you think might make a great print, take it at high resolution, such as1280 x 960 pixels. Smaller file sizes let you get many more pictures on a memory card. Bear in mind that you can't add information to a picture at a later stage—but if you take a high-resolution file, you can always reduce its size and resolution in the computer.

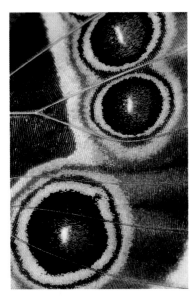

Capturing details
To capture as much detail as possible, set the resolution to fine TIFF or even RAW, if your camera allows it.

Caught in action
The author in his natural habitat! For this shot, the camera was set to JPEG (fine); I normally use TIFF or RAW, although in practice it makes little difference, unless you are going to make a very large print.

MEMORY CARD SIZE	JPEG Basic	JPEG Normal	JPEG Fine	TIFF 3MB no compression
8MB	26	11	6	1
16MB	53	22	12	2
32MB	106	45	24	4
64MB	213	91	49	8
128MB	426	182	98	16

25 How big should I make a file when taking a picture?

The size of file to aim for is largely governed by what you want to do with it. Small file sizes are all you need if you are just going to look at your pictures on a computer screen. If you need to make prints, then you need bigger files to give the finer detail. If you set your sights on getting work published or on producing leaflets or any other publicity work, then magazines and printers demand 300dpi and large files to give the detail required. The table below shows approximately how big files should be for some common uses.

Large print (above)
If you want to produce a large print (say, 8 x 10 inches) on your home computer and inkjet printer, then you will need a file in the region of 10 MB.

Sunflower center (right)
It is better to set too high a file size than to set one that is too low and then find you cannot make the print that you want. If you think a shot may make a good print, use the highest resolution that your camera can provide.

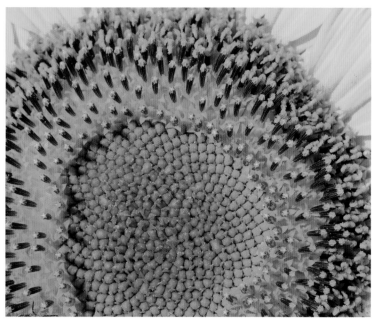

USE	IMAGE SIZE	FILE SIZE	
Web pages	480 x 320 pixels	0.45 MB	
screen resolution 72 dpi	600 x 400 pixels	0.7 MB	
	768 x 512 pixels	1.12 MB	
	960 x 640 pixels	1.75 MB	
Prints and illustrations	**PRINT/ ILLUSTRATION SIZES**	**PRINT 200 dpi**	**MAGAZINE 300 dpi**
	3 x 5 in	1.72 MB	3.86 MB
	4 x 6 in	2.75 MB	6.18 MB
	8 x 10in	9.16 MB	20.68 MB
	5 x 7 in	5.5 MB	12.45MB
	8 x 11·5 in	11 MB	24.9 MB
	11 x 16 in	22.1 MB	49.7MB

26 How much of the frame should my subject fill?

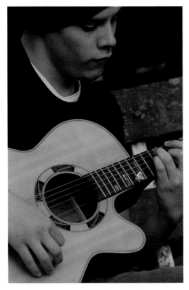

Shooting something large enough to fill the frame makes a huge difference to your prints. They will be sharper if you don't need to do any extra cropping on screen, as enlarging the original image can result in loss of quality and detail. From a compositional point of view, filling the frame as much as possible makes your subject more important in the picture and also cuts out extraneous detail, resulting in a "tighter" composition. For example, if you set individuals or even groups of people in a huge expanse of beach or fields, they look too small and insignificant in the frame.

Of course, how you choose to compose the image is a personal decision and will depend on the effect you wish to achieve. But always avoid taking pictures against a background that is too cluttered. Moving in close will help exclude any messy, distracting elements. You can, however, overdo it and get too close: including some background makes a nice frame for portraits, for instance. Some subjects can give you dramatic pictures if you are so close that you "overfill" the frame, eliminating all border and background detail. Photographs of nature subjects, patterned material, or textures such as wood and stone, become abstract when they fill the frame, and make great screen savers.

Guitarist (top)
To show an activity (people at work or play), close in just enough to show the person and what they are doing within the frame.

Insect close-up (above)
If ever you want to identify a natural history subject later from books, you need to able to see distinguishing details.

Leaf veins (above)
If your camera will let you get really close, then you can create abstracts such as this set of leaf veins. Angle your camera or zoom closer or further away until you have created a pattern that appeals to you.

27 Should I use the camera with the viewfinder frame horizontal or vertical?

Traditionally, a horizontal shot (with the longest part along the width of the frame) has always been called "landscape" format because that is what it was believed to be best suited to. Turn the camera through 90° so that the long side is vertical and this is "portrait" format—you can see why, since faces are longer than they are wide, especially when you include head and shoulders as well. But with photography "rules" are for breaking: you can use landscape format for people shots, and vice versa, and when you choose to do so will depend on your subject matter. Check the composition in your viewfinder or on the LCD and decide which format is best.

As a general rule, if your subject is wide the landscape format is best; if it's tall (a tree or a tower, for example), portrait format will be suitable. Large groups of people lend themselves to a landscape format, but for an intimate portrait of seated figures try portrait format. If you have a panorama setting with a very wide frame you could try turning this vertically for dramatic pictures. The examples given on these two pages show you the range of effects that can be achieved with different subjects.

Horizontal format for groups of people

With two or more people in a frame, the horizontal format usually works best. It is important to move in close and exclude extraneous background details where possible.

Flowers in the landscape

Regardless of whether you are shooting a vertical or a horizontal picture, try to lead the eye into the frame. Fences, paths, and buildings can all help you do this and make the picture more interesting.

Subject shape

When you are deciding whether to opt for a portrait or a landscape format, be guided by the shape of your subject. Often, subjects that are taller than they are wide work better as a portrait format, while landscape format suits wider subjects—but break the rules and see what happens!

28 What's the best place to position a subject in the frame?

Sunset, portrait format
In landscapes, you need to balance the sky and the land. To emphasize the sky, position the horizon about one third of the way up the frame; to emphasize the land, the sky should end about one third of the way down. Avoid placing the horizon across the center, as this cuts the image in two.

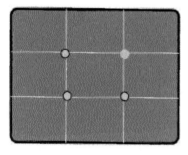

The "rule of thirds"
The yellow circles on the diagram show the strongest points at which to position your subject in a composition,

Poppy center
Experiment! If it seems obvious that a flower center should be in the middle of the frame, try placing it slightly to one side instead. In fact, do both and decide later which you prefer.

Successful art or photography often means grabbing attention—and, even more, leading the eye to the point of interest. Classical painters understood this and used rivers, fences, rows of trees, or fields of waving corn as devices to pull your attention into the picture and then your eye instinctively follows them. You can include such devices when choosing where to position your subject in the frame. Things that are arranged diagonally in a frame, such as grass stems, fences, and branches, give a sense of movement, even if the objects themselves are stationary. These are the little things that make your pictures stand out. You can use an overhanging branch, an archway, or even a shadow to frame your subject, too, so that attention is drawn to it.

The most obvious place to put your subject is dead center in the frame—the bull's eye shot. But surprisingly, placing a subject slightly off center gives a better "feel." Go one step further and don't just offset the subject to one side of the center—do the same up or down. This compositional effect is called the "rule of thirds" (see diagram below): the view is divided by imaginary lines that run vertically and horizontally across the image to create a grid. Placing your subject at the intersections of the lines creates a more pleasing composition, although the placement doesn't have to be exactly on the intersection to create the right effect.

29 My pictures sometimes come out too dark or too light on the LCD. How can I control this?

When exposed correctly, your pictures should appear as bright or as dark on a computer screen as they do on the LCD, and you can effectively use your LCD as a sort of visual exposure meter. If, however, all your scenes are too light or too dark on the LCD, compared to how they appear on screen or in reality, then you may need to re-set the LCD screen through the camera controls. The various camera menus in your instruction book will let you change the screen adjustment. Make small changes when sitting in the kind of lighting in which you would normally view the LCD screen, and adjust through trial and error, comparing the image on the LCD screen with those that have been downloaded.

Correct exposure
Ideally, your pictures should look the same on the LCD as they would in a print, so you can use the LCD to check if the exposure is right. Most cameras have a menu that lets you change screen brightness; refer to your instruction manual.

Overexposed shot
If the image looks light and washed-out, it is overexposed and you need to decrease the exposure by using the minus (-) setting on the exposure compensation button.

Underexposed shot
When the picture looks dark, you need to increase the exposure by using the plus (+) setting on the exposure compensation button. It is better to underexpose than to overexpose, because you retain detail and can adjust things later on your computer.

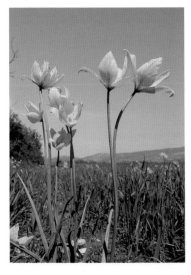

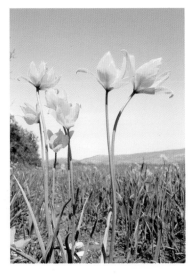

30 Sometimes my digital camera does not get the right exposure balance—between white dresses and dark suits at a wedding, for example. Can I change this?

Neither film nor digital cameras can handle the differences between very bright and very dark objects in the same frame. With most digital cameras, setting the camera on auto, so that the sensor in the camera "looks" at the scene and averages the brightness, works very well. However, if you have very bright or dark things in the frame, the meter tries to make the bright or dark things an average gray—so you get under- or overexposed shots respectively.

At a wedding, if the bride is wearing a white dress, the exposure meter reads the scene with a large amount of light, decides it is very bright, and adjusts to compensate, resulting in dark faces and a gray dress. Similarly, when there are large dark areas the meter will decide you need more exposure and any light subjects will be burned out. Don't give up—compromise: it is better to have faces you can see and recognize. The great thing about digital is that, provided all the information is in the digital file, you can make changes later when you see things on screen.

More sophisticated cameras take readings from several segments in the viewfinder (known as matrix metering), so there is less risk of the meter being fooled. If your shots still come out too dark, increase the exposure time: if they are too light, decrease it. Use the exposure compensation button and adjust until the picture on the LCD looks right to you. Most cameras let you adjust at intervals on a + and − scale (see Question 9; page 20). To make things brighter go to the plus side: to darken things go the other way.

High-contrast scenes (above)
In a scene that has both light and dark areas, it makes a difference where you point the camera. If you point it at bright subjects, the dark areas will become too dark; if you point it at light subjects, the highlights get burned out. Always use the LCD to check.

Graduation day (right)
Exposure is always a compromise. In shots of people, the skin tones need to be right. Skin tones that are slightly too dark look tanned and may be acceptable; bleached-out skin that is too pale is not.

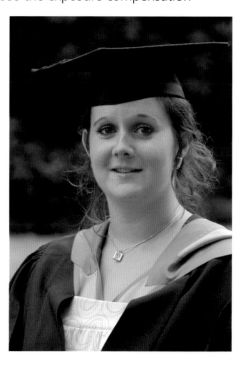

31 **When I take landscapes on auto setting, either the land is exposed properly but the sky looks too bright, or the sky is right and the land is dark. What's the solution?**

This is the landscape version of the wedding dress problem (Question 30, opposite). In a landscape with a bright sky and dark land, the exposure meter gives the middle route and you lose out on highlight and shadow details. There are some ways around this, enabling you to capture enough information to make further adjustments later on your computer. It is easier to lighten a dark landscape than it is to darken a burned-out sky.

If you want to capture a dramatic sky, then tilt the camera so that the ground occupies a smaller proportion of the frame. To take a reading for the land, making sure the sky occupies a smaller part of the frame. You can then increase or decrease the exposure via the compensation button to get a better result.

If you want both sky and land and you have a fairly straight horizon, then you can use a gray graduated filter. Move the filter until the gray part is over the sky, which brings exposure times for land and sky into the same ball park. This sort of technique works better on an SLR where you can see exactly what you are getting through the lens; otherwise it is guesswork.

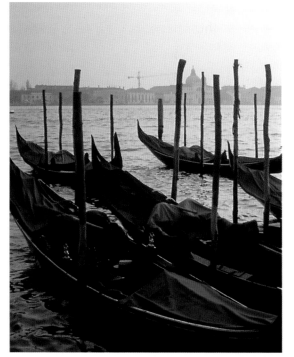

Scene with light and dark areas (above)
To avoid the risk of the camera's built-in meter assuming that the whole scene is very dark and overexposing the shot, take a meter reading from a mid-tone, such as the interiors of the gondolas, and lock the exposure; you should then be able to retain detail in both the bright sky and the dark sides of the gondolas.

Bright scene (right)
When you are shooting a snow scene or other bright subject, there is a risk that the built-in meter will underexpose the shot. Take a reading from a mid-tone, such as the trees or people's skin.

32 How do I make everything in my photograph look sharp?

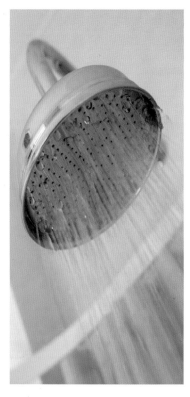

The impression of sharpness is helped by getting a few things right. First, you have to focus the camera carefully. If your camera has auto focus, then most cameras focus on the center of the picture and so a subject that is placed off center might not be sharp if it is closer or further away from the camera. In this situation use a smaller aperture (a bigger f-number, see Question 33, opposite) to get more of the foreground and background in focus—known as depth of field.

If a picture lacks sharpness overall, then you might have camera shake. Use a higher shutter speed, a tripod, or some other support (see Question 16, page 30).

Good lighting is also a key ingredient to making things look sharp and is often forgotten. Dull pictures never look sharp even if, technically, they are. Lighting things slightly from the side creates small shadows that make things look sharper; using a flash off camera helps, too (see Question 15, page 29).

Slow shutter speed (above)
This shot was taken for a web brochure. The shower head is sharp, but at $^1/_{15}$ sec. the shutter speed was slow enough to blur the water. A faster speed would have frozen the water drops.

Keep the camera back parallel to the subject (right)
When photographing butterflies with open wings, choose your camera angle so that the camera back is roughly parallel to the open wings to ensure you get wing-tip to wing-tip sharpness.

Close-up mode (right)
When the camera's close-up mode is set, the lens aperture is automatically selected to give increased depth of field. The shutter speed drops and you may need to use a flash to avoid camera shake.

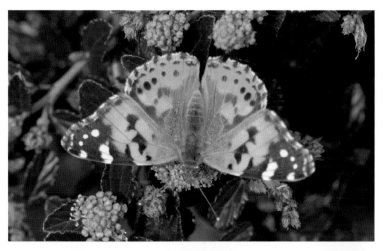

33 How do I get just part of my picture sharp?

Understanding apertures

Traditionally, photographers have used a scale of f/numbers to note the aperture, starting with the widest (f/1) and ending with the smallest (f/32): 1; 1.4;2; 2.8; 4; 5.6; 8; 11; 16; 22; 32. The difference between one aperture and the next is known as a "stop." These features are often found on more advanced SLR digital cameras.

Artistic blur
When going for shots with an artistic blur, make sure that something in the picture is bitingly sharp so that your subject is recognizable.

To control sharpness in this way you have to understand depth of field—how much behind and in front of a sharp subject things stay in focus. You can alter the amount by varying the size of the lens aperture. To isolate a background subject, set a high f-number (and decrease the size of the lens opening); to pull a foreground subject into focus, decrease the f-number (see the box). Basically, small apertures give a lot of depth of field and wide ones give shallow depth.

When you move in close, it is technically impossible to get everything in focus. You have to select which parts you want to be sharp. When there is an animal of any sort (including humans) in a shot, the eyes must be sharp. Get that right and your brain forgives things that are out of focus. With a dog that has a long muzzle, you will find that eyes and nose tip can never both be in focus—so take your shot slightly from the side. This has the effect of reducing the effective distance between them from your camera's viewpoint and you can get them both sharp.

34 I want to blur the background to make the subject stand out. How do I do this with my digital camera?

There are two ways of doing this—first, by using your camera and a few photographic skills and second, by manipulating the image in the computer.

With portraits or shots of flowers or birds, a soft background blur makes the foreground appear sharper and adds impact to your pictures. The basic technique is to use a shallow "depth of field"—this means the subject is in sharp focus and anything behind it falls off quickly into a blur. Use the widest aperture you can on the lens—something from f/2.8 to f/5.6, for example. Panning is another technique, described in detail in Question 35, opposite.

The effect is more pronounced if you isolate your subject with a telephoto setting on your zoom or with a telephoto lens. Wide-angle lenses take in a bigger field of view and appear to offer much more depth, yet if your subject is the same size in the viewfinder, the depth of field is always about the same at a particular aperture, whatever lens you decide to use.

Changing backgrounds is one of those things you can do in a photo manipulation program when you have mastered the technique of selection.

The fun of the fair (top)
A fast shutter speed would freeze movement—but use a slow speed (e.g. 1/8th sec.) and the subject is blurred in a way that suggests action.

Natural blur (above)
The odd duck-head shape of this fennel plant is accentuated by using a wide aperture to isolate it from the background.

35 I've heard about panning. What is it and how do I do it?

Panning is the business of moving the camera with a moving subject to keep it at the same point in the frame and is another method of achieving a blurred background with a sharp subject.

You may wonder what the point of doing this is when you can use a fast shutter speed and freeze everything—both subject and background. The advantage of panning is that you keep a sense of movement in a shot because you don't use a fast shutter speed: the subject comes out sharp because you follow it while the camera is taking the picture. But the stationary background blurs as you move across it, giving a clear subject against a background that is blurred by the movement of the camera.

First attempt (above)
Not quite right—panning takes practice. In this shot, the subject is coming towards the camera so I had to change focus and pan at the same time: a camera with predictive autofocus will do this.

Second attempt (right)
It is much easier to stand side on and pan. You have only one camera movement to worry about and the picture is sharper. My willing subject did not mind taking the extra rides!

36 Why is there a delay when I press the shutter button before I hear the camera click and the picture is taken?

We are used to an instant response from a film camera where you press the button and the shutter fires. When you first use a digital camera, the "soft" response is disconcerting—you press the button and there is a noticeable delay. However, delay times are getting shorter as advances in technology are made.

The problem lies with the digital sensor: it is is known as a CCD, or charge-coupled device, and it has to be given an electric charge before it works. It can't store charge for nearly long enough and so the camera's circuits do it just after you press the shutter—hence the wait. For landscape shots this delay isn't really a problem, but you will have to learn to make allowances when taking pictures of moving subjects, such as children or animals, to capture the shot you're after. Alternatively, you can take a series of shots and hope that you've caught the magic moment in one of them.

top tip

To reduce the delay, preset the camera to auto focus and preset the white balance.

Capturing the moment
The slight delay between pressing the shutter of many digital cameras and taking the picture is time enough for facial expressions to change. Here, the subject was entirely unaware of the camera—so the delay wasn't a problem.

37 Some people say you can't take pictures in quick succession with a digital camera. Is this true?

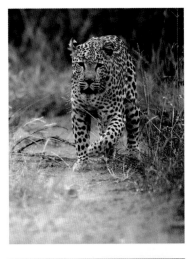

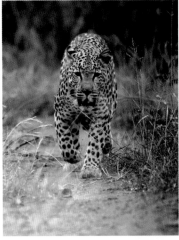

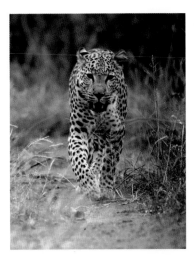

It is possible to take a succession of shots with some cameras that have the capability of continuous shooting. Many cameras now have a "buffer" that allows you to take a few pictures in a burst. If you think you might want to take sequences of pictures, then look at the camera specifications in one of the numerous photo magazines that publish camera details.

Check the figure for the "burst rate"—the number of frames taken per second (fps). This gives the number of pictures you can take before the camera has to "rest" and write the shots to its memory. Before that, it stores them in a secondary memory called the "buffer," so you don't have to wait for one picture to be written before the next is acquired.

Some cameras also offer a longer period of continuous shooting—typically 40 frames at 1.8fps. You will have to accept a lower picture size, typically around 1 megapixel (1280 x 960 pixels), as the same buffer has to be filled but with less data per picture and quality will suffer. Some cameras, notably Fuji's, offer a Top 5 and Final 5 option: go for the first and you get five shots in rapid succession. Final 5 just retains the last five shots—great when you have to anticipate action.

Leopard in action
When animals are moving, your picture will change from one frame to the next. Most cameras allow only a short burst unless you buy a top-of-the-range SLR intended for sports photography. Until you view the sequence, you have no idea which frame will appeal most. Timing is everything.

jargon buster

Burst rate—the number of frames shot per second (fps). For example, 5 fps takes five shots in one second.

Buffer—secondary memory where images are stored before being compressed and stored in the memory on the flash card.

CCD—charge-coupled device, the digital sensor that needs to be charged a picture can be taken.

38 To photograph sporting events, do I need a digital camera that takes a long telephoto lens—or can I use the built-in zoom and enlarge the picture later?

Shoot from a distance!
With some subjects, it's much safer to shoot from a distance with a telephoto lens! With a fast-moving subject that's traveling across the frame, as here, you need to pre-focus and allow plenty of space to the left and the right to be sure of getting the subject in the frame. The camera was also panned (see Question 35, page 55), so the background looks slightly blurred, which helps to create a sense of movement.

You can have a lot of fun with a compact camera at sporting events, as long as you wait for the action to come to you or move around the periphery of a games field to get the scoring moments. A typical 3–5 megapixel compact camera might have a built-in zoom that provides the equivalent of a 35mm–115mm lens on a film camera, giving a modest wide-angle to portrait zoom.

Set the resolution to JPEG fine and default ISO 200 and you can enlarge part of the picture later by 2 to 3 times to close in on the action and still get a highly acceptable print. You are, in effect, creating your own digital zoom on the computer.

If sport fascinates you and you want to get anywhere near emulating the professionals, then nothing less than an SLR will do. With a 6 megapixel SLR you can enlarge even more later and get the same quality you might with the compact, or use a telephoto lens from 300–400mm focal length (on many digital SLRs this is equivalent to a 450–600mm film lens). The weight and length of the lens means that you will also need a tripod, and permission for using it with some authorities.

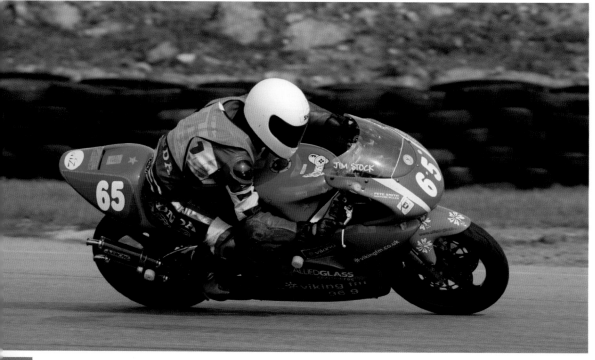

39 How can I capture split-second action? Is it just luck?

Yearling catching fish
Photographer Chris Weston specializes in capturing large animals in action. To anticipate the moment, you need to understand how the animal behaves: luck is just a small part of it. Subject position and behavior can also change from one moment to the next, so you need a camera that recovers fast enough to let you take shots in rapid succession. Only the more expensive digital SLRs have a high "burst rate."

Luck does sometimes play a part—but experienced photographers try to maximize their chances of getting shots in one of two ways. First, you never quite know where in a cycle of events you will get THE special picture, so shoot a series. Some top-of-the-range digital models can shoot a whole series of photos fast enough and leave you to choose the perfect shot later (see Question 37, page 57).

Second, you have to know your subject. The best animal photos, for example, are taken by people who study their subject for a long time before they set out to take pictures. With sports shots, the best photographers understand the sport so well that they can, to a large extent, anticipate what is going to happen next.

Start by thinking about the kind of shot you want to take: visualize it—put yourself in the best position you can, have the right lens on the camera, select the right shutter speed and aperture. Set the exposure to auto and use auto focus. With moving subjects use predictive auto focus if you have it. That way, all you have to do is to press the shutter and maybe move the camera slightly to change the frame. If you leave yourself with too much to do at the last minute, you will lose the moment.

40 How do I take time exposures and get myself in the frame, too?

Putting yourself in the picture involves using the timer on the camera. First you have to put the camera on a support, such as a tripod, so that you can set it up and then get yourself into the frame. Don't make the composition too tight, as this allows you some leeway if you don't manage to get into exactly the right position. You can always crop the picture later. Also make sure you leave long enough to get into the frame and relax.

There is nothing quite like a blinking light on the camera as the countdown takes place to generate fits of giggles. This can sometimes work to your advantage, however, and give very happy shots. The chances are that you will need several attempts because someone will always be looking away from the camera, yawning, grimacing…but the great advantage of a digital camera is that you can review each shot until you get one that you're happy with.

Father and son
My son and I wielding picks during a summer of endless digging. I placed the camera on a tripod and set the timer before leaping back to grab the pick.

41 **At parties and in crowds I've seen people hold a digital camera above their heads to get pictures. Any hints on making this work?**

With a film camera this type of shot will always be hit and miss. The LCD on a digital camera gives you a few clues as to what you're pointing at, but there is still an element of guesswork. Your best bet is to take a shot at the wider end of the zoom range, so that if you point too high or too low the subject is still there. One advantage is that you can take a shot, check it on screen, and make any adjustments. Also, if the final shot is tilted you can always adjust it later on the computer.

Always take a few shots to give yourself more chance of capturing the moment—passing celebrities, the band in a parade, the lead singer of a rock group as he launches into the crowd… Start shooting a little before you think the best shot will occur and, if necessary, take a number of shots in quick succession (see Question 37, page 57).

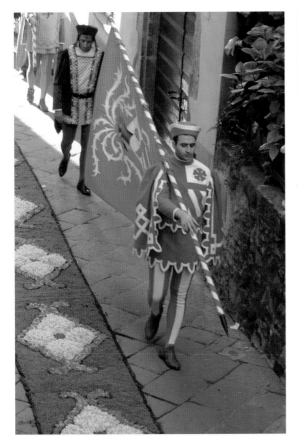

Everyone loves a parade
Often the best view of parades and crowds is from above. Here a convenient window looked down on the scene below.

Time to talk
Getting too close would have broken the spell. Here a telephoto lens used from a balcony captures two old friends sorting out the world's problems.

42 When I photograph groups of people indoors, I get dark backgrounds—just as I did with film. Can I avoid this with a digital camera?

Dark backgrounds occur when flash lights up only the things in the foreground. This cannot be avoided when you use a small flash, such as the one built in to your camera. You could invest in a more powerful flash gun (see Question 15, page 29) if you think you will use it often enough, or use the slow synch mode for flash, if it is available as a feature on your camera (see Question 14, page 28). The shutter runs more slowly so you get some background light as well as the ultra-short exposure of the flash.

Alternatively, you can adjust the sensitivity of a digital camera—the ISO setting—easily. Set it higher than you would outdoors so that you can make use of the ambient light inside. You can use the flash as the main light source but get enough light in the background to prevent it from going black. Not all cameras allow you to do this. Take an exposure without using the flash and look at the shutter speed and aperture that the camera chooses, then set values just below these in manual mode; the flash gives the main light, but the camera will pick up ambient light, too.

Deliberately dark background (above)
Sometimes a dark background can actually enhance a shot. Here, it allows the baby, nestling in the crook of her mother's arm, to stand out from the background. Check the picture on the LCD display to see if you're happy with the result.

Slow synch (right)
For this shot, I used the slow synch mode on my camera's built-in flash, which leaves the shutter open after the main burst of flash has fired, allowing light from the window to illuminate the background of the scene.

43 If I want to photograph a big group of people at a wedding or party, what sort of arrangement works best?

Professional photographers make the business of group photography look deceptively easy—they have to impose their personality on ill-disciplined, raucous, outgoing elements (if your friends are like mine…) So, have you got what it takes or do you know nice, obliging folk? Often at weddings the prorfessional will set up the group, do the shots, and then the guests get a chance, too. Don't try and compete—watch for the moments just after the picture is taken when people start to relax…

If you have to set up a group yourself, two traditional arrangements work well. You can place the tallest people in the center, descending in height toward the outside of the group. Or you can arrange people in ranks, with the tallest standing at the back, others (the venerable and mature) sitting, and perhaps young children on the floor in front.

A natural prop, such as a staircase, lets you arrange people in ranks and is great for the informal shots—which, after all, is what most of us prefer.

Staircase grouping (above)
A staircase provided a convenient "stage" for arranging this informal group. The only problem then is to get a picture without silly expressions or heads being turned in different directions..!

Harvest time (left)
An old tractor proved a magnet for attracting a group of adults and children at a May Day celebration. No attempt was made to get everyone to look toward the camera; I simply recorded people as they were, engrossed in what they were doing.

44 I want to take portraits of my children and their friends. What's the best way of posing them?

The simple answer is—don't! The worst thing to do is sit them down like the school photographer would and wait for the cheesy grin—because that is what you will get. Get them doing something: children involved in an activity are fascinating subjects because they concentrate to the exclusion of everything else.

A zoom lens is a great help here because you can focus on a group of children as they play or zoom in on one. Take lots of shots (after all, you're not wasting film) and edit later; if you wait for "the moment," as photographers say, then you're sure to miss some great shots.

Always try to fill the frame with the subjects. It is the one thing that makes your pictures look more "professional."

A word of warning: stick to your own family, or the children of friends, and only take photos with the parents' knowledge and permission. It is safer that way for everyone concerned.

Lost in thought (below)
Whether they are camera-conscious or not, children are often easier to photograph when they engaged in some kind of activity.

Budding pianist (below right)
The grand piano was a magnet for this young visitor; the minute the camera appeared she posed beautifully.

45 Which is the best way to take a portrait—face on, slightly to the side, or another way?

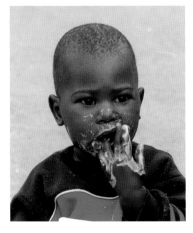

Face on (above)
A face-on portrait immediately engages the viewer.

Options (below)
Portraits can be anything from a part of a face through to full length—so try different options.

Like so many things in photography, you never quite know until you take several versions and compare them. Sometimes a portrait that shows a slight sideways tilt of the head, with the eyes looking directly at the camera, works well. Most of us do not have symmetrical faces—noses bend more to one side than another, eyes are at different heights, and so on.

It is for this reason that you hear people say they have a "good side." Go with it and allow your subject to choose (even if you don't agree) because they will be much happier and more relaxed—and then you can gently suggest photographing the other side just to see.

A direct frontal gaze can have a lot of impact. For this you need to get the lighting right—more from one side than another (but not so much that you get shadows from the nose and in eye sockets). Seating someone beside an open window provides you with good portrait lighting. Many digital cameras allow you to use flash as well and, after a few tries, you will get a good balance of natural and artificial light. Remember to watch out for distracting items in the background.

46 How much of the figure should I include in a portrait—head and shoulders only, three-quarter length, or full length?

If you had just one shot and could not decide, then you could take a full or three-quarter length shot and crop it on your home computer. But the result is never the same as taking a head-and-shoulders shot in the first place. And the reason comes down to perspective—with the closer shot you either stand closer or use a zoom to bring the subject closer. The further away you stand. the "flatter" the result; the closer you are, the more you will accentuate the facial features.

If you want a head-and-shoulders shot—which is often the best way of displaying the face—then take it there and then. I never quite know what I want with a subject, so I try a whole range of shots and then select.

One thing to remember is that if you move in close to your subject for a head and shoulders shot, there is much less chance of including distracting objects in the background, which you are more likely to get if you step back for the full-length shot.

Keep your options open (top)
A three-quarter length shot like this gives you the option of cropping later to a head-and-shoulders shot or even closer.

Private moment (above)
A head-and-shoulders shot captures the intimacy between mother and daughter.

Three-quarter length side view (right)
Here, a three-quarter length portrait meant that the subject's expression was clearly visible and left enough space on the left of the shot to show off the dramatic mountain setting.

47 I don't like "posed" people pictures. How can I get good, informal-looking shots?

top tips

Talk to your subject, put them at ease

Let them get on with what they are doing

Place your subject in surroundings familiar to them

Family group

People who know one another find it easier to relax. Make sure people in group shots are not too far apart, otherwise it looks strained.

The secret is to make your subject feel relaxed. This is easiest if you know the person in question, but good portrait photographers can quickly put people at their ease. People relax more easily in familiar surroundings—at home or in a work place. And if you photograph people while they are occupied with something, you generally get a more interesting shot—gestures are natural and not forced.

Try to catch people unawares before they become self-conscious and avoid them looking directly at the camera. If you are seating a subject to photograph them, get them to sit on a stool or edge of a desk or table, which both looks and feels more informal.

"Looks conscious" teenagers are not easy to photograph. One option is to let them take their own shots, using the camera's self-timer, and experiment until they are happy. The older we get, the more most of us settle into our looks. Elderly folk often make wonderful subjects, the sitters are used to their wrinkles and accept them!

48 How does the "red-eye" adjustment work?

This procedure is quite ingenious and it involves a firing a burst of flash just before the main one. The red eye is a reflection from the blood vessels on the back of the retina when a subject is looking directly at the flash. The pre-flash makes the pupil of the eye smaller, so there is less chance of reflection and the resulting "red-eye" effect.

If you don't have this adjustment, then make sure your subject is not looking straight at the camera. Alternatively, use a flash to the side of the camera. Failing this, you can always try retouching the image on your computer and some programs have a procedure ready made for this.

Tom kitten (left)
Like human eyes, a cat's eyes reflect light. When you are using flash, you need to make sure it does not look unnatural.

Wise owl (above)
Eyes are a point of immediate contact with humans and any other animal. It is essential that you get the eyes pin sharp or the portrait simply does not look right.

49 I want to take a black-and-white picture. Should I do this through the settings switch on the camera or later on the computer?

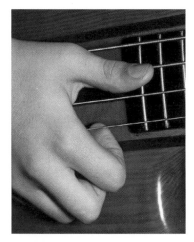

Some cameras offer effects settings such as black and white, sepia, document, and borders. They are certainly not essential to good picture taking, for everything can be done later when you download. Many people try them once and then never again.

When you set any of these switches the camera processes the result and loses data. For example, to make a black-and-white picture it loses all the color information. You can't get it back—so in many ways it is sensible to do any color changing later when you have seen the picture on screen. That way you have the color version and can make any other shot you want from it.

There is no need to change resolution when you use an effect—but you can get away with lower resolution in a black-and-white or sepia-toned picture and create a "grainy" effect that works very well.

Simplicity (top)
Black-and-white photographs have a simplicity that shows shapes and forms free of the distraction of colors.

Revealing texture (above)
There is nothing like black and white for revealing textures. This shot was taken in color and then the color data was removed using Image > Mode > Grayscale. Contrast was increased for the final print.

50 My digital camera has a close-up mode, but when I use it things look blurred. Where am I going wrong?

You are probably being too ambitious and trying to move closer than your camera can focus. Some cameras will not let you do this and the shutter locks when you are out of range—so just move a little further away and try again. Blurred images in close-up mode can also occur when the lens aperture closes down to give greater depth of field but the shutter runs slower to make sure there is enough light to expose the picture. The result is camera shake.

The slightest movement, either from your hands or from a breeze on the subject, can also create blur. Steady yourself by putting the camera on a tripod or holding it against something. You can also set a higher ISO rating; this will increase the shutter speed, but the trade-off is that you get a more grainy image.

Gerberas (top)
So-called close-ups are possible with virtually all digital cameras. How close you can get depends on the model—but most can cope with shots of groups of flowers.

Soft-focus iris (right)
To achieve this effect, focus on part of the subject with the lens wide open, so that the depth of field is small.

Lily stamens (above)
A few cameras offer a real close-up mode, allowing you to take pictures of subjects a few centimetres from the lens. You can do this with any digital SLR using a macro lens.

51 I want to take close-up shots, but only a very small part of the image seems to be in sharp focus. How can I get everything sharp?

This is the challenge with all close-up work, but it is not impossible to achieve. Manual control can help: as you make the lens aperture smaller, you get greater depth of field. This allows you to get more in front of and behind your subject in focus. The closer you get, the smaller the front-to-back distance gets—and at life size it is just a few millimetres. So, try to use the smallest aperture your camera will allow. Remember that there is always a compromise to be made: you don't want such a slow shutter that everything blows around and blurs your picture. Many people who take close-up pictures work with flash, because the flash freezes movement and you can use a small aperture.

For all close-up enthusiasts with an SLR camera the answer has to be the macro lens, which is specially computed and corrected to function close up. Most macro lenses that are meant for film give life size (1:1) scale of reproduction, which means that the subject is the same size on film as it is in reality. A digital SLR has a magnification factor of 1.5 (see Question 13, page 26) because the sensor is smaller than 35mm film frames, so using a macro lens on a digital SLR gives an image 1.5 times life size.

Orchid (opposite, top)
When you are very close to a subject, any tiny movement seems gigantic. Always use a steady support and, where possible, take pictures in calm conditions.

Sunflower (below)
Choosing the point of sharp focus is important. If your camera allows, set the aperture to its smallest size to achieve maximum depth.

Seed heads (opposite, bottom)
Try and make a pattern in your picture. Even if you can't move the subject, you can arrange it in the frame just by turning the camera or by changing your viewpoint.

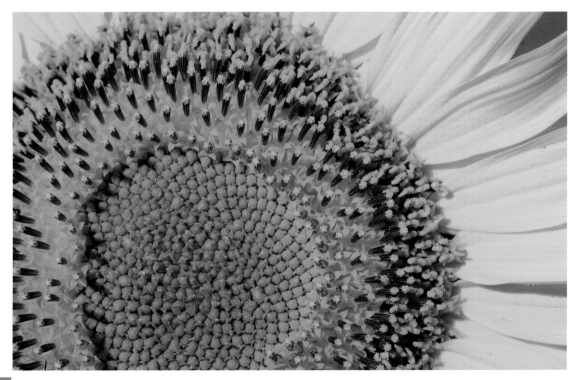

52 How do I make panoramas by "stitching" together digital images?

Since you are going to create one big picture from several elements, those elements have to match. The question is how best to do it. A little bit of forethought will make producing panoramas by "stitching" on your home computer much easier (see Question 83, page 112).

overlap—all the elements in the picture must overlap to some extent, otherwise there will be spaces between the different sections of the panoramic image. It is not hard to judge this when looking in the viewfinder. For example, if you see a tree in the right-hand part of the frame, make sure the same tree is clearly in the left-hand part of the next frame. Stand on level ground and swivel, moving your feet slightly and not rotating your body, so that the camera is always at a constant height (this way you won't have to do too much cropping or adjust horizon levels). Best of all, use a tripod with a head that you can set level and then rotate as you take each picture.

focusing—don't change it and don't zoom. Set the focus when you begin to shoot the sequence and use an aperture

that keeps both foreground detail and the distance in focus. If you correct focus or, worst of all, zoom, then you will have some pictures at a different scale from others. In theory you can correct this with your software, but life is too short…

exposure—try to keep the same exposure in each shot, so that areas of light and dark are recorded as they were. For this you have to lock the exposure or set it manually; if you don't, then you will have to readjust the sliders at the manipulation stage to match brightness and this is usually visible in the end result. Avoid getting the sun in the frame when it is high in the sky, as the camera cannot cope with the differences in brightness. Sunsets pose different exposure issues (see Question 54, page 77).

The process may sound complicated, but the beauty of digital photography is that you can take as many trial shots as you need to set the camera controls. Then just stick to them and take the shots.

Taking photos for a panorama
Make sure you allow enough overlap between the constituent parts.

53 My camera has special settings for the beach or for snow mode. Do I need them or are they just a gimmick?

Snow and large areas of light sand reflect a lot of light and this can fool the camera's exposure meter. The meter is fine for coping unaided with "average" scenes where things are not too light or too dark. With snow or a bright, sandy beach, it sees the scene as brighter than it is and the results come out underexposed. The snow and beach modes simply adjust the meter to compensate.

If your camera allows it, you can do the same manually by changing the lens aperture (see Question 33, page 53). If snow dominates the picture, then you'll need from 1 to 1.5 stops overexposure. If you don't have a snow mode, take the exposure from subjects that are lit in the same way— skiers' clothes or buildings, for instance. Lock the exposure and then shoot your scene.

Over-bright beaches
Whenever you set your camera to do something on auto, it uses information programmed in. For beaches, the tendency is to get dark pictures because the sky and the sand are bright—so the camera deliberately over-exposes; the same thing happens with snow.

Using the exposure lock
If your camera has an exposure lock point at the area in which you want detail, such as the sand, and hold down the button while you shoot to get the correct exposure.

54 Sunsets look dramatic but my digital camera does not always give me the colors I remember. Can I change this?

You are asking a lot of your digital camera at sunset: if the sun is still in the sky, then the camera has to capture a wide contrast range from very bright to dark. First, make sure the ISO is set to its lowest value, so that you can capture all the subtlety of the tones. Then experiment. Take the first exposure at the camera setting. Then try and compensate—underexpose slightly and then overexpose by the same amount on another frame using the exposure compensation button (see Question 9, page 20).

If you have an exposure lock, take a reading from different parts of the scene, lock them, and take the picture you want. You'll see a huge difference. Some of them won't be the colors that you saw, but they will be so rich and glorious that you will want to keep them. If you have a sunset you like, then you can make subtle changes on your computer, such as putting in a bit more yellow—the sorts of changes that happen as the sun gets lower.

Experiment (top)
With a sunset always experiment: underexpose to get deeper colors, especially just after the sun goes down. And take lots of shots: the light is changing all the time.

Convenient frame (above)
Trees in silhouette can provide a natural frame for your sunsets and for other shots in which skies predominate—but try to avoid large, solid dark areas.

55 When I take photographs of buildings, everything looks as if it's falling over. Can I change this?

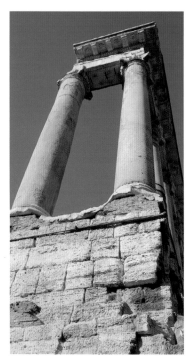

Once upon a time, nearly every photographic magazine and book dealt with what was called the problem of converging verticals. Nowadays people are not so hung up about it and many shots of buildings show a distinct convergence since it accentuates the impression of height. With the widest setting on your zoom lens, you can stand beneath tall buildings and get them to tower over you.

If you really want to minimize the effect, then you have to be level with the middle of a building—taking the shot from a window opposite, perhaps. If you point the camera up or down, the verticals either converge or diverge respectively. Some computer programs can adjust the problems of converging verticals, too.

Converging verticals (left)

Once upon a time, converging verticals were frowned upon. Now they are an accepted part of a composition. In fact, stand in front of a tall building and convergence makes it seem to soar.

Corrected shot (below)

To correct verticals, first try standing somewhere slightly further back and higher up so that you can see your subject without pointing the camera upward. Alternatively, you can correct perspective in the computer—but it takes a little practice to drag "frame handles" and get it right.

56 **When I use my digital camera inside large buildings, the pictures seem slightly red. Should I adjust this in the camera or later on my computer?**

You get an overall color cast when you have a scene where the light sources are mixed, such as daylight from windows and interior incandescent lamps. You can adjust this effect through your camera's controls, or later in the computer—but it is always better to try to start with as near perfect an image as you can.

If your camera has its white balance set for daylight, then under tungsten lights things will take on a reddish or yellowish hue that in moderation looks like "warmth." To reduce this you can set the white balance function to auto and let the camera sense a balance between the light sources. It is worth seeing if you can do better when you use the fine-tuning function for white balance where you can adjust the color temperature in steps. You have to judge things from the LCD screen, and many of these are fiddly to set up properly.

One way of working is to shoot using RAW mode in camera so that it records as much information as possible. You can then change the white balance until it looks right on screen.

Mixed light sources
Where there is a mix of daylight and artificial light, set the white balance on your camera to auto to give a compromise white balance. If this is more toward the artificial light, then any part illuminated by sun will be redder. If this is unacceptable, take another shot with the white balance set to shade or incandescent.

57 Is it possible to take indoor pictures with candlelight or the glow from a fire?

The answer is a resounding "yes." However, although your eyes see perfectly well, these low light levels are often outside the range of the camera's exposure meter, so you will need to experiment. The exposure will last several seconds at least—so set the camera on a tripod and trigger the shutter using a cable release (pressing a shutter button shakes the camera).

First, use the camera's meter. You will have to wait for the shutter to close. From the result, guess whether you must increase or decrease the exposure (lengthen or shorten the time the shutter is open).

Candlelight is very yellow and that from a glowing fire, red. You might have to adjust the white balance for "realistic" colors, though the effect is often pleasant without any adjustment.

Flickering light (above top)
Your eyes are much more sensitive than a camera and quickly adapt to low light levels. A camera, on the other hand, will require a long exposure to record the detail—so you are likely to get some flickering of the light.

Adjust colors with the white balance (above)
The camera's own auto exposure provided the picture: the white balance was set for "incandescent" and gave a good result.

Backlighting (right)
Move the camera to capture the reflections in the wine glass. Slight changes in position affect the way the wine is lit.

58 What setting should I use on the camera to photograph stained-glass windows?

Arched rose window (below)
Even if a church is lit by artificial lights, any stained glass is backlit by daylight from outside. There may be a slight problem with bright areas being burned out, but this is easy to correct using exposure compensation and by looking at the LCD screen.

Set up the camera as you would for daylight photography, because that is what illuminates the window from behind. Change the white balance setting to "cloudy," because this warms up colors and there are often reds and yellow in stained glass that benefit from this.

Use the LCD as your "visual exposure meter": if the shot is too light, underexpose it a little; if it is too dark, overexpose slightly. Sometimes it is hard to see the result on the LCD screen, so err on the side of underexposure. This way, you will catch subtle details in the window that will become apparent when you view the image later on your computer screen.

Check what's outside! (above)
This old window in a town house backed on to a wall outside, which I did not notice until I checked the picture on the LCD. For this shot, I chose a part of the window that was backlit by the sky.

59 I know a small built-in flash isn't powerful enough to cope with large interiors, but could I get another flash to work automatically with my camera?

It is possible to attach a separate flash to some more advanced digital cameras via a hot shoe—but even with a big "hammerhead" flash gun, it will be difficult to illuminate the interior of a very large building such as a cathedral. Many such places also restrict the use of flash photography, so you need to turn to your camera's many settings to help you circumvent the problem.

In your digital camera you have a versatile tool that can do the job for you quietly and unobtrusively without flash. Find something—a column or wall—to lean against, and raise the ISO rating to 400–800. The resulting exposure will be long, so you will need to support the camera to avoid camera shake.

The camera's built-in flash is fine for snapshots of nearby subjects, although deep backgrounds will not receive any illumination so they will appear dark in the photo.

Often a better alternative is increasing the camera's ISO setting and bracing the camera to allow the use of a slightly slower handheld shutter speed. By using this technique both the subject and background will be more evenly exposed.

60 How can I avoid reflections when I try to photograph things behind glass?

top tip

Always ask permission before taking photographs in galleries or public collections.

Tree frog

For this vivarium shot, I pressed the lens up against the glass and focused beyond; this way, spots on the glass do not show up on the image. To avoid any bright reflections from the flash, I held it above the tank.

Reflections from glass can be cut using a polarizing filter, but this is only reliable if you have an SLR which allows you to see the effect as you rotate the filter.

Try standing slightly to one side of your subject—although this is not effective when you want to photograph a painting, because it will appear skewed on screen. (This can be adjusted on the computer but it is convincing only if the distortion is slight.) In some galleries you can stand in relative shadow and take the picture—that way you are not illuminated and don't create an obvious reflection on screen.

When photographing glass cases and aquaria, use a hood around your lens (I have used the water collector from a drainpipe painted matt black!). Black velvet or flock paper with a hole for the camera lens works well. Press your lens front up against the glass so that you avoid reflections. This works well provided the glass is clean; if there are any smudges or marks on the glass, they will not be in focus, but they will soften the image.

61 How can I take digital shots at night?

Although street lights look bright to you, this is just because your eyes adjust to the light levels. To help your camera cope, use an ISO speed of 400 or higher. If you use less, then you will hear the shutter act slowly, giving more than enough time for camera shake. To get enough light the camera lens will have to be wide open. This means using a large aperture—and a program mode will do this for you.

It always helps to have a support—with low light level shots use a tripod or a monopod. But even a wall (horizontal or vertical) or a friend's shoulder to brace the camera is better than nothing at all, and much less trouble than a tripod.

It is hard to "freeze" movement at night, because a person or car might move as the shutter is open. Work with the blur, let it be part of your composition to suggest movement. Car lights, for example, leave "trails" that can look very effective.

A flash is great for lighting a subject—perhaps a face—in the

Car-light trails
Headlights and tail lights of traffic make great patterns when you leave your camera with its shutter open for several seconds. You'll need to use a tripod.

foreground, while the street lights provide the background. If the subject is too near it may appear burnt out. Try it and see how your camera copes. Some cameras allow you to underexpose and you can then fine tune the exposure until the face is properly exposed.

Full moon
A full moon is bright. At ISO 100 an aperture of f8-f11 and an exposure of around 1/125 sec. and will give a good result. However the moon is moving, albeit slowly—and this movement enough to create a picture that is slightly fuzzy. Set the ISO rating at around 400 and the exposure at 1/500 sec. at the same aperture, and use a telephoto lens if you want to capture the craters.

62 When I use the built-in flash, sometimes the shots are too dark or too light. Why?

Small, built-in flash guns are a great idea, but it is easy to get out of range with them. Your subject may be too close for the aperture that has been set (so the shot comes out too light) or too far away (so it comes out too dark). Realize the limitations of a built-in flash and it will work wonders for you.

If your subject is too far away, the flash just won't give enough light and the result is dark. First, try using a larger aperture (see Question 33, page 53). If the photos are still dark, then set a higher ISO value to make the camera more sensitive. If this fails, then they are too far away and no one would recognize them anyway—so move closer.

At the other end of the scale, if you use a wide aperture close to your subject, you can flood it with light and get overexposure. Usually, closing down to apertures of f/8 or less solves the problem. Changing the flash mode to slow synch will also help to lighten areas of the shot. Alternatively, adjust the exposure compensation setting (see Question 9, page 20).

Correct flash exposure
The Phalaenopsis *orchid is a typical close-up subject for your digital camera. If the flash exposure is correct, you'll get a very sharp result with good, saturated colors.*

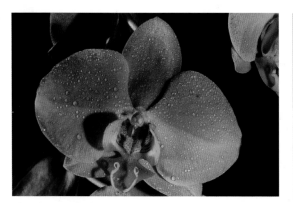

Shot is too dark
If the picture is too dark (under-exposed), first go to the exposure compensation button and add a whole stop on the plus side. If this doesn't work, the chances are that the aperture is too small—so use a wider aperture (a smaller F-number).

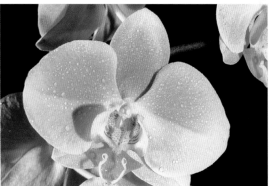

Flash was too close
If the flash is positioned too close to the subject, the photo will be overexposed and will look washed out. Use aperture priority mode on your camera and set a smaller aperture (f/11—f/16) and see if this works.

63 Firework displays always look as if they could make good pictures. Can I photograph them with my digital camera?

The best firework pictures are taken with the shutter open for anything from from several seconds to a minute or more. Exploding fireworks create very bright spots of light, so you need to use small apertures, such as f/16 or f/11, if your camera lets you set them. A long exposure is necessary so that when the firework trails spread, they "write" their picture on the sensor and you catch the whole cascade.

If you are interested in this type of night photography it may be worth purchasing a camera that has a bulb, or B, setting whereby the shutter stays open for as long as the shutter release is held down. By letting the shutter stay open for a minute or more, you could catch several fireworks in the same shot.

For a challenge, try and include someone watching the display in the picture. Even if the shutter is open for a few seconds that won't be enough time to expose the face—so help things along using the camera flash. Set the camera to "manual" to capture the fireworks as before, and use a flash exposure to light up the face, making sure your subject does not move while the rest of the picture is being taken.

Framing your shot (below)
It's impossible to predict exactly where in the sky fireworks will explode, so take a wide-angle shot to be sure of capturing a large area and crop later if necessary.

Bulb setting (right)
Use the "bulb" setting, if your camera has one, to leave the shutter open for a minute or more and capture the trails of light.

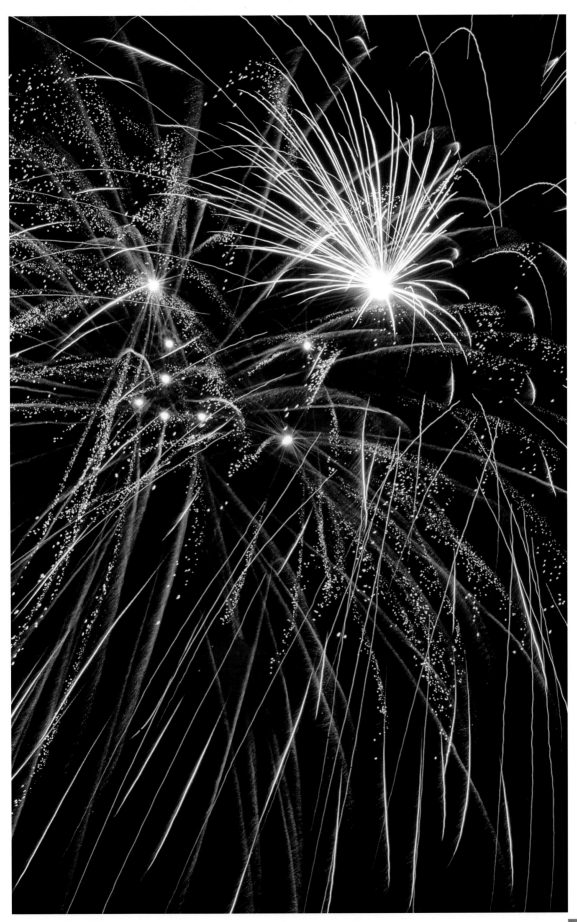

64 Can I use my digital camera under water with a housing—or should I use a disposable camera?

If you have never tried taking pictures under water before, then disposable cameras are a great way to start, as they work very well near the surface where there is enough light.

Digital cameras are ideal for underwater work since you can fit a large enough memory card and not have to come up to change a film after 36 pictures. Specialist firms make secure housings from acrylics or other plastics that provide a sealed environment—controls are accessed from the outside via knobs. Housings depend on "O" rings and other seals to make them watertight; these have to be perfectly fitted and checked regularly to make sure they do not perish.

Octopus in rock pool (below)
You don't have to take your camera below water for marine pictures. I spotted this octopus in a rock pool.

Eliminating surface reflections
Surface reflections can be eliminated by using a polarizing filter and rotating it until you can see below the surface. This works with digital SLRs and cameras with a video viewfinder

Rock-pool photography
Rock pools are great for small details. With your camera's close-up facility, it is easy to record bits of weed and colorful small sponges such as these. Make sure you don't disturb the water or it will cloud up and show on your pictures.

65 My digital camera operates on batteries. Can I use it in very cold weather?

Mechanical cameras that were used in very cold conditions used to suffer because the lubricants became more viscous and slowed down shutters unless they had been replaced with special ones before a trip. With digital cameras the difficulty is they depend so much on batteries—and all cells discharge far more rapidly as temperature is lowered. There is nothing you can do about it, other than protect the camera from cold.

You can use a heavily insulated case, but it is easier and less expensive to remove the batteries or battery pack between picture-taking sessions and store them in your clothing as near to your body as possible. For cameras at the "professional" end of the market, you can get separate battery packs and run a cable down your sleeve from snug battery to camera.

Winter scene
The one drawback that many people find with a digital camera is that it relies solely on battery power—you have no mechanical back -up. To avoid the problem of your batteries running out just when you need them, use rechargeable batteries and always have one set on charge.

66 If I pack my digital camera in my hand luggage, will it be affected by X-ray equipment at the airport?

There is no real evidence available to suggest that airport X-ray machines affect digital cameras or damage memory cards. There is some concern about metal detectors, since they employ magnetic fields that can affect digital devices—the hand-held wands used by airport personnel are the main suspect. Some people suggest placing your camera as far away as possible from the beginning of the conveyor belts that carry items through X-ray machines to avoid powerful magnets in the drive motors. According to the U.S. Transport Security Administration:

"None of the screening equipment—neither the machines used for checked baggage nor those used for carry-on baggage—will affect digital camera images or film that has already been processed, slides, videos, photo compact discs, or picture discs... The screening equipment will not affect digital cameras and electronic image storage cards."

X-ray scares
Most of the fears about X-rays hang over from film cameras. The image file here was one of many on a CD in a wallet that I'd forgotten I was carrying. It passed several times through the powerful hold X-ray machine with no ill effects.

Playing safe
If you have a laptop or portable CD writer, then you can back up images easily. This file and many others disappeared when a suitcase was lost in transit while I was traveling home from an assignment. Fortunately, I had made a back-up set of CDs and mailed it home.

67 If I use my digital camera at the beach, how can I protect it from sand and salt spray?

It goes without saying that water and electronics don't mix—and salt water is even worse than fresh. If you drop a digital camera in water, the repairs could cost more than a new camera. At the beach the air contains salt spray, which is harmful to the camera's electronic systems if the body is not completely sealed.

Never wipe a lens after using the camera at a beach until you have given the front surface a few puffs with a blower brush, or better still, an "air propellant," to remove tiny abrasive sand particles that will scratch your lens surface. Leaving a camera lying on sand or a beach towel is asking for trouble. A protective case is essential and, for good measure, put it back in a bag.

Salt spray
If you take a lot of photos near the sea, then a soft plastic housing might avoid the need for expensive repairs later on. Salt water and electronics do not mix.

On the beach
To avoid tiny grains of sand working their way into your camera, keep it in a plastic bag when it is not in use—and never leave it on a rock in the sun.

68 If I want to take pictures in a hot house or in a humid atmosphere, how can I stop the lens misting up? Will the moisture harm my camera?

The mist on the lens front is condensation—tiny water droplets caused by the camera lens being colder than its surroundings. If you let the camera warm up in the hot house, the problem will go away. There are anti-misting sprays available of dubious efficacy, so when I was working on regular assignments in hot houses, I always traveled to the venue with my camera bag in the front of the car near the heater—prewarmed.

Prolonged exposure to high levels of moisture does a digital camera no good, for moisture and electronic circuitry do not mix. More expensive cameras have "O" ring seals, but the only solution with most cameras is to put the camera back in its case after every shot. After you leave the hot house, take out the camera and wipe it down carefully. If you are staying in a hot climate then store the camera with some sachets of silica gel. This absorbs moisture and needs to be heated above 100°C to drive off the moisture to be effective.

Butterfly
Butterflies in a hothouse sit just out of reach, so your telephoto mode will come in useful. Stay near nectar plants and try to catch the insects feeding. Many butterflies open their wings when they are basking in sunshine.

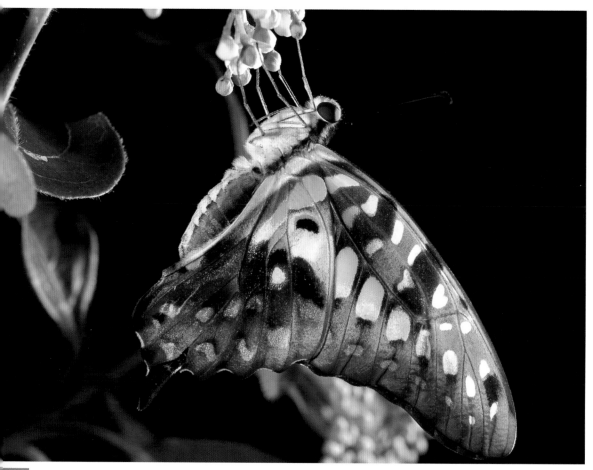

Hidden dangers!

This creature is harmless—although it does not look it! Far less innocuous are the molds that attack everything in tropical conditions, Keep cameras in cases when they are not in use and, on prolonged visits, pack things with silical gel to remove moisture.

Orchid

Many of the most intriguing flower subjects are tropical—orchids especially. Camera lenses will mist up when you go from a cold room into a hothouse so allow time for the camera to warm up and check the lens to make sure lens condensation has gone before you take pictures.

PART 3

From camera to computer

Taking the photo is only the first part of the digital story: add an inexpensive PC, a color printer, and some easy-to-use software, and you have control of the picture-making process from start to finish.

This section explains how to transfer your photos onto computer and how to carry out some simple adjustments to improve them. It looks at various ways in which you can use your photos, from e-mailing them to family and friends to making high-quality prints that you can hang on your wall and including your photos in magazines and brochures. Finally, it sets out ways of archiving your images, so that you can retrieve them quickly and easily, and explains how to store them safely.

Total control
With digital photography, complete control of image making is in your hands from start to finish.

Source Images

Use: Frontmost Document

Choose...

☑ Include All Subfolder

Document

Page Size: 20.3 x 25.4 cm

Layout: (2)5x7

Resolution: 28.346 | pixels/

Mode: RGB Color

☑ Flatten All Layers

Label

Content: None

Custom Text:

Font: Helvetica

Font Size: 12 pt

Color: Black

Opacity: 100 ► %

Position: Centered

Rotate: None

Picture Package

1 of 198 items selected 15.54 GB available

Layout

Click to select a custom file

Edit Layout...

69 Can I use and store digital images if I don't have a computer?

The advantage of a computer is that you can edit and manipulate your photos and e-mail them easily. If you don't have one, however, there are excellent storage devices that allow you to download, store, and view your images.

portable CD writers—these have a screen and allow you to write in "sessions," so you can download several times and burn onto a re-writable disk each time. On screen a series of disk icons come up. A CD icon appears on screen: on a Mac you just drag all the files you want to burn onto the icon and a box appears showing that the files are being copied. When that is done, go to FILE and click on "burn CD". On a PC using Windows XP, you can open the control panel and drag your files to the CD icon there.

home DVD players—allow you to read and view the images on CD.

stand-alone printers—you can make prints directly from the CD without a computer, either by using one of the stand-alone printers for this purpose or by taking them to your local photo store. Some stores are equipped with machines that allow you to view, select, and print yourself. A stand-alone printer can be connected to a computer if you want, but you can also load image CDs into it to view them on a small screen and print them.

portable printers—devices such as the Tatung Elio Photojukebox, are neat, portable, and will store and play MP3 music files as well as display your pictures on a 2.2-inch viewing screen. The Innoplus Phototainer comes in several versions up to 80GB; you can output direct to a television screen and set up slide shows.

Field work
If you do a lot of work in the field, small portable storage devices with an integral screen to view an image collection are ideal. You can download to a computer or play direct on a television screen.

70 How do I connect my digital camera to my PC or Mac?

Firewire ports (above)
Mac computers and many others offer Firewire "ports," which permit a very fast transfer of data from camera to computer or between computers and portable hard drives.

Location work (below)
Some photographers find that a laptop computer is invaluable, particularly for location work, since you can use it to download, store, and edit images on a much larger screen than your camera's LCD in the evenings after a day's photography.

Every digital camera comes with a port—a socket that allows you to connect cables that transfer data—which you connect it to a computer with a special lead. You need to know which kind of port is on your computer and which is on the camera before you buy cables. Early digital cameras had a "serial" connector and download took ages, and these connectors are still available on almost every computer, PC or Mac, in some guise or other. However, there are several different cables now available that make downloading files much quicker:

USB (Universal Serial Bus) and **USB2**—the beauty of USB is that it is "plug and play:" when you connect a device, the computer recognizes it immediately without the need to reboot (start the machine again). You can connect lots of things to your computer via separate USB sockets and, if you don't have enough, then a card for the PC slot or an external device called a "hub" lets you connect more by giving you extra sockets. USB2 is very fast.

When you connect your digital camera to your computer, the USB connection essentially wakes up the software you use for transfer, known as "hot swappable."

Firewire (IEE1394)—is very fast, although it is claimed that USB2 offers equivalent speed, and you can chain a series of devices together without "terminators." Firewire began on Macs, but Firewire ports are now built into a lot of PCs, too. You can add cards with Firewire ports to machines that do not have them. Firewire comes with different end connections, 4-pin and 6-pin being the most common.

Sony cameras require an ilink, which is essentially a Firewire cable with a socket.

71 What type or size of media card can I use?

What size of image do you need?
Think about how you will use the image. A 1GB Compact Flash card will store 296 fine JPEGS—the equivalent of eight 36-exposure films from a 35mm camera, which is perfect for quick snapshots—but if you need to retain a lot of detail or shoot large files for publication, which was my reason for taking the two shots on this page, you will soon fill up the card.

top tip

If you own two digital cameras, then it makes sense to have the same kind of memory card for both.

A media card is the rewritable, removeable memory that you use to store photos after you have taken them and before you download them to a computer or some other device. All types of memory cards are fitted into a slot in a camera and digital images recorded on them. The most common types are:

Compact Flash Cards (CF cards)—the most widely used. There is a wide variety of choice for card readers and capacities from 8MB up to several MB. The best value in terms of price per stored image come in the 64–128MB range. Think carefully about what you need for storage—size isn't everything and some cards give you higher capacities but noticeably slower writing speeds.

SmartMedia have the advantage of being very light and compact, although they are also wafer thin and rather fragile. It is the camera's internal circuitry that determines the number of pictures you can store, so you can't get bigger capacity cards. They store up to about 128MB.

Micro-drives are electromechanical drives that fit into CF type II slots and are suitable for people who want fast cards that store large files. The largest have a capacity of 1GB (1000MB) and more. Remember: the bigger the card, the more there is to lose if something goes wrong.

PCMCIA cards (Personal Computer Memory Card International Association) are physically larger than CF, SmartMedia, or Memory sticks but have the advantage of being readable in a PC card slot. Images are captured and stored after the card is inserted into the camera's PC slot. Eject it and you can then copy the images to the computer via its PC slot, using the software supplied.

Sony Memory Sticks are great for Sony aficionados because they can be used both in their video and still cameras. Few independent card readers are available and you are essentially committed to the Sony system. They are not as widely available as CF cards, tend to be more expensive, and capacities range from 8—128MB. In use, make sure that the erasure prevention switch is in the "off" position so that images can't be accidentally deleted. Again,

the images are copied to computer via a card reader that is supplied with Sony's own software.

To help you decide, think about the size of images you will be taking and their ultimate use, such as printed photos, images for e-mail, or pictures to be published. If you restrict your picture taking to medium JPEGs, then a 128MB card will store a large number of images (see Q00); for fine JPEGs, 256MB is suitable, but if you shoot large TIFFs or RAW files on a top-of-the-range digital SLR, then 512MB or even IGB will soon be filled.

jargon buster

media card—the portable memory used in digital camera that is small and almost thin enough to be a "card."

card reader—a device connected to a computer into which cards are slotted to download the images stored on them.

flash memory—the type of "solid state" memory used in image storage.

CFII type slot—a slot that takes CFII (Compact Flash) cards, the most widely used cards.

Snapshots
For snapshots of things you come across on your travels, a 128MB card may well be sufficient.

72 Is there any advantage to using card readers compared with just plugging in my camera to a computer?

When you plug a card reader into your computer, it is seen by the computer as another hard drive. They are now so popular that they have become inexpensive and have the advantage of freeing up your camera when downloading. When you are busy taking pictures you can simply take out the card, slot it into the reader, and download to a computer. If you connect the camera direct (via a cable), then you cannot use the camera while the images are downloading—and with a large-capacity card, this could take some time.

A number of readers cope with multiple card formats, and they are often faster than a cable connection. The Sandisk 8-in-1, for example, can take Compact Flash I&II, SmartMedia Memory Sticks, and more via a series of slots.

The advantages of a card reader
A card reader makes it more convenient to download regularly and free up space on the card in your camera—particularly when you are shooting high-resolution images.

73 How do I decide which image manipulation program to buy?

Versatility

With an image-manipulation program, you can change many things—size, color, sharpness, to name but a few. You can even remove things you don't like and add others, while creative filter effects allow you to produce weird results.

Many of the available image-manipulation programs do the same things: you can load in an image, crop it, make different enlargements, make color changes, correct blemishes, and sharpen the image.

Rather than show a confusing array of examples of every available program, the examples in this book are from Adobe's Photoshop Elements. This cut-down version has many of the features of the full version of Photoshop, and is easier to use. It is widely packaged with scanners and printers, making it easy to get hold of a copy. It will do most of what you ask from it, especially if you get out of the auto modes when you get used to it.

To help you choose a program, decide what features will be important to you, and make sure that the program covers all the basic functions, such as downloading, cropping, resizing, and color correction. If possible, try a program first, perhaps from free downloads or give-aways in software magazines, before you buy it.

Which program?

There are many image-maniupulation programs on the market, but Photoshop Elements worktop is particularly well thought out. "Quick fix" options let you make basic corrections quickly and effectively. As you gain confidence in using it, you will find there is little that you cannot do to your images with this program.

74 How do I get an image into the program and up on screen?

Whether your images are loaded on a CD or downloaded from your camera directly into the computer's hard disk, getting a picture on screen is just like opening any other file.

Some computers have a default program that opens pictures. Alternatively, you can view your pictures using the program that comes with the camera software.

One useful way is to use whatever program you have for image editing and manipulation. Through the preferences dialogue box (usually found in the Edit menu on the file bar) you can set the program to open when you click on an image or when you download. You can use Photoshop Elements to open a file containing images: go to File > Open and then find the image as you would any other file.

The right connections
A simple connecting cable (USB or Firewire) carries data from your camera to computer. Image editing software allows you to set it to open when the camera is connected, so that your pictures are imported directly where you can work on them.

75 The image is on screen in front of me. How do I resize it or crop it?

In Photoshop Elements, select the tool bar that has crop and selection tools. To crop, click on the crop tool and the pointer changes to a small rectangle. Click the mouse and drag to enlarge the rectangle by placing the cursor on one of the sizing handles on the image; drag at the corner of the rectangle and it increases the whole area, drag in the middle of the sides and it lengthens in that direction.

Placing the cursor inside the rectangle lets you move the whole image. The area left is clear while the surround is masked—so you can see what you you are going to get. Press return to confirm and the crop is done. You can set the crop tool to give fixed-size crops as well or use the rulers at the frame edge.

To resize and image, go to Image > Image Size, where you will see a dialog box where measurements can be shown in inches, centimetres, millimetres, or pixels. At the top

Restoring picture size

When you crop a picture to change the composition, the portion that is left is reduced in size. It is easy to make a print. Go to Image > Resize and adjust the resolution and picture dimensions. If the file size grows (top figure) you are creating pixels; up to 50% more makes little difference to the appearance of the final print.

you will see the file size for the picture on screen, with its dimensions in pixels below—useful if you are sizing for the web, for example. Most of us work with normal measurements for height and width in the next boxes when making prints. Check Constrain to maintain the ratio of length to breadth without cutting or squashing the picture.

Underneath is the resolution—72dpi for screen pictures, 180dpi (or 200)–300dpi for prints, and 300dpi for photos that are going to be published. As you change the numbers, keep an eye on the figure at the top: if this gets bigger than the file size before you start adjustments, you are adding pixels and these have to be interpolated (see Question 1, page 10). You can allow for 40–50percent more.

Cropping

Cropping allows you to cut out parts of a picture that you don't want. Click to select the "crop" tool from the tools palette. A rectangle will appear on the picture and you can then change its size by clicking and dragging on the sides to change the width and height, and on the corners to increase the whole size in proportion. Experiment to see what looks best.

76 When the image is too dark or too light on screen, how do I change this?

From the menu bar, select Image > Adjustments and then Brightness/Contrast. A dialog box opens, with a slider for brightness at the top and one for contrast below. Make sure you check the preview box so you can see the effect on screen; for best results, you will need to use brightness and contrast together until you get it right.

This approach works well for lots of pictures and is a quick-and-easy solution, but it can be a little heavy-handed. For more subtle fine-tuning you can use one of two routes in the same Adjustments menu—Levels or Curves.

Both Levels and Curves have an auto option that gives some idea of how they work, adjusting a balance between brightness and contrast at the same time. You can do this for the whole picture or select one of the color channels (Red, Green, or Blue) for some weird and wonderful effects. If you are keen to experiment, then open Levels: you will see maps called histograms, which show colors and their proportions and can be adjusted by means of sliders. In Curves you get just that—a curve for each color. Move the cursor to the curve and then hold down and drag to adjust the colors individually.

Correct exposure

"Correct" exposure creates a balance in all areas of the picture so that there are details in both the light and the dark areas

Overexposure

With overexposure, light areas appear burned out. Detail is lost, and you cannot retrieve it by manipulating the image.

Underexposure

With underexposure, a picture is too dark but a lot of the image information is still there and you can "lighten" it.

77 My pictures lack contrast. How can I give them more punch?

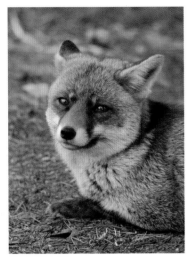

Original shot
This fox arrived by the roadside under trees, where light was low. No flash was used and the picture lacks contrast; there should be more difference between the light and the dark areas.

Black and white images often suffer from lack of contrast. Select Image > Adjustments and then Brightness/Contrast. You will see a contrast slider—move it and see what happens. Down at the left-hand end (decreasing contrast), things get a bit muddy and gray, with little difference between light and dark tones. Moving the slider to the right (increasing contrast) makes the blacks pitch black and the whites pure white, with not a lot in between. Adjust the slider to achieve the desired effect.

With color images, the image breaks up into sharp blocks of color at both extremes of the slider scale, creating an image where there are no subtle changes in tone and some areas become blocks of solid color—an effect known as "posterization." You will get the best results from subtle changes of brightness and contrast—for instance, making something slightly darker (moving the brightness slider to the left) and increasing contrast (using the contrast slider) gives a more "punchy" effect. Experienced Photoshop users go to Levels and Curves for more control, but most of the time brightness and contrast do the job for you.

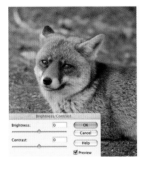

No adjustment
Assess the image: if it looks flat and dull, change the contrast.

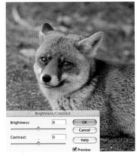

Auto adjustment
The imaging program can assess contrast automatically and correct—but is the result what you want?

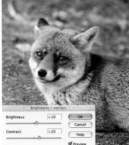

Slight adjustment
Make gradual changes: often just a slight tweak will give more contrast.

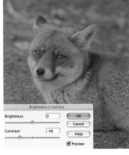

Low contrast
Experiment to see what happens at the ends of the slider: with really low contrast, everything is dull and lifeless.

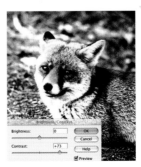

High contrast
With high contrast, blocks of color replace smooth tones.

78 Some images seem to have a color cast. Is it possible to remove or change it?

Original

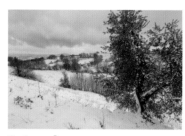

Auto color

Desaturated

Oversaturated

Color casts
Photoshop Elements can correct casts automatically or you can take control yourself—from de-saturation to remove all color and create a black-and-white image to oversaturation, which exaggerates all tones. Color casts are easier to recognize and correct where there are white areas in a photograph.

This is where digital photography really scores. Ideally, your computer monitor should be set up to give accurate colors that match what is recorded on your camera. There is a utility in Photoshop that will calibrate the monitor for you, for example, so that when an image is on screen you can see whether the colors were as you thought.

Sometimes, however, they don't match—and the reason this happens is down to the type of light in which the photo was taken bright light from a blue sky with snow or a shot taken indoors with a mix of incandescent or fluorescent lamps, for example. In these situations, snow can appear too blue and human skin can have a reddish or magenta hue. Your camera has a white balance adjustment, which can help at the time you take the photo (see Question 17, page 31), but it is often easier to adjust things on the computer.

The simplest fix is to go to Image > Adjustments, then Hue/Saturation, where you will find a box with sliders for hue, saturation, and lightness.

Hue—is color
Saturation—is the brightness of a particular color
Lightness—is an overall brightness control

Make tiny adjustments—too much and the change is dramatic. You can work on an individual color in the primaries Red, Green, and Blue (RGB) or their complementaries Magenta, Yellow, Cyan (CMYK), by selecting with the edit box in Hue/Saturation and using a slider to change overall cast.

This is not the most subtle route and many people use Curves, where you can adjust individual color channels. To increase blue, drag the BLUE curve up; to reduce blue and increase yellow (its complementary colour), drag the curve down. To increase red, drag the RED curve up; to reduce red and increase cyan (its complementary colour), drag the curve down. To increase green, drag the GREEN curve up; to reduce green and increase magenta, drag the curve down. It sounds complicated but is actually very easy.

79 Can I rescue an image that is out of focus?

Using Unsharp Mask
You can rescue soft images to some extent by using the sharpening facility but do not expect it to perform miracles. The sharpening filter picks tiny changes in contrast and accentuates them. Make a print to see what the changes look like, as it's not easy to tell from the screen. Above all, be subtle and avoid oversharpening.

Oversharpened image
Here you can see the unnatural-looking effect of oversharpening.

You can't get away with poor photography and rescue every blurred image, but you can make an image sharper on print or crisper on the computer screen by going along the menu bar to Filters. Select Sharpen and you will be given more options to try such as sharpen, sharpen more, sharpen edges, but the most useful is Unsharp Mask (USM). It sounds as if it will throw everything out of focus but it doesn't.

There is a dialog box where the first thing to do is check Preview so that you can see changes on screen. Unsharp Mask assesses color and brightness changes and makes them more obvious—putting in darker pixels, for example, a little like working on a painting and putting tiny black lines around things to accentuate them. It is more subtle than that, but the effect is remarkable. The settings (Amount, Radius, Threshold) to use depend on how big the file is—use too much USM (the % control) with a small file and it looks very grainy. Use different settings for different purposes, for example:

Large files from an SLR (17MB TIFFs):
Amount: 120–200%; Radius: 1.5–1.8; Threshold: 1–3
Screen pictures 600 x 400 pixels, JPEGs at 72dpi:

Amount :80%; Radius: 1–1.5; Threshold: 8
Experiment and see what suits you—and don't just try on screen: make prints and keep them for reference.

Keep the eyes sharp
When taking pictures of faces of any sort—humans or other animals—the eyes are the most important part. If they are not sharp, then the image won't look right—although you may not know why.

Not fixed

auto sharpened

80 Can I remove people, telephone wires, and anything I don't want—or even add things to an image from another image?

Removing blemishes

The leopard had a bloody nose— from a scratch or from its last meal. To correct a blemish, zoom in on the detail using the magnifying tool. Photoshop Elements has a "clone" tool that picks up pixels from other parts of .the image. Dust spots and marks can be removed in the same way.

One of the most useful tools in Photoshop Elements is the Clone Stamp Tool, which is found on the tool bar and lets you take pixels from one part of your picture (or from a completely different picture) to another part. So to get rid of telephone wires, just pick up pixels from beside the wire and drop them over the wire to obscure it. To remove someone from a photo, drop pixels from the background over the offending figure. Want to put in a figure? Pick up pixels from another picture and drop them in carefully—making sure that both pictures are the same scale, unless you want the figures to look out of proportion.

When you select the Clone Tool, the menu bar at the top of the screen changes and from it you can select the size and type of brush. A slider scale alters the brush size—the area of pixels that you pick up. Enlarge the portion of the image on which you want to work, using the magnifying glass tool on the toolbar. Click on the Clone tool on the toolbar and select Clone Stamp. Then click the Clone Stamp onto the pixels that you want to copy, move the stamp to where you want the pixels to go, and click again to drop the pixels where you want them. You can choose a brush that has soft edges from the menu, which will blend things better and make the insertion less obvious.

What makes all the difference is the time you take. Use a small brush and work on little bits at a time. Try not to move in straight lines, even with wires, since this shows— especially if you sharpen the picture later. One of the best ways to practice using your skills in dropping pixels is to take out blotches and scratches on old negatives— "touching up." With just a little practice, you can become very proficient.

81 If I don't like the sky or background in a shot, can I change it without it looking obvious?

This involves using a process called selection. Use a magic wand from the tool bar to select a range of colors, or draw round the area that you want to change with a "lasso," or magnetic lasso. When the area has been selected, it will be surrounded by a flashing dotted line (so-called "marching ants"). You can fill it with another color using the paint bucket tool or work on it through the Quick Fix or full Edit menus to change the color balance, alter the brightness, or even sharpen (or blur) it.

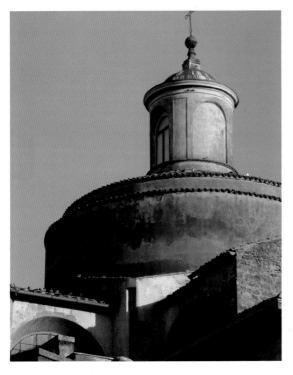

Original shot
When you look at an image on screen, a sky or some other part might not be quite what you remember. Don't worry: you can change it.

Color variations
The Color Variations option lets you see what various small color changes produce. Click to select the one that looks best to you.

Selected area desaturated
The program allows you to change anything within the selected area. Here the color contrast has been adjusted.

Magic wand selected
Use the magic wand tool for areas of uniform color. Click on the area to select and you will see a flashing dotted line ("marching ants").

82 How do I add text to the picture and make a card?

In Photoshop Elements you can use a feature called Layers, which you'll find on the main menu bar. It's a bit like adding a sheet of transparent acetate above the main picture and putting your captions, labels, or greetings onto this sheet. Create a new layer and then select the type tool ("T") on the tools menu bar. This creates a text box. Once you've keyed your text into this box, you can enlarge it, change the font, and add some impressive-looking effects through the Layer Styles.

Many people already have some sort of drawing program on their computer and it is easier to use these. Start with a clean "sheet" on screen and then copy your picture into by dragging the open photograph into the page. Now you can treat it like any other drawing. Create a text box that you can click on and drag wherever you want. In the box, type your greeting, set the font and size, and style the color.

Adding text
One way of adding text to a picture is to use a separate layer. It's rather like drawing on a clear plastic sheet and laying it over a picture—but you can change the font, its size and appearance.

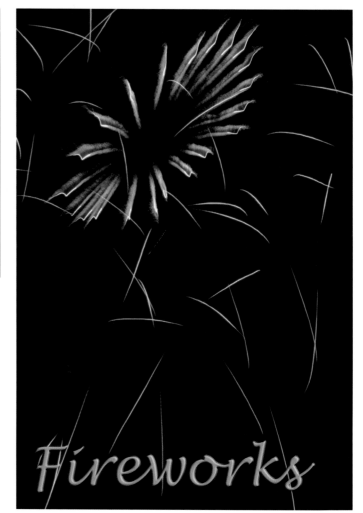

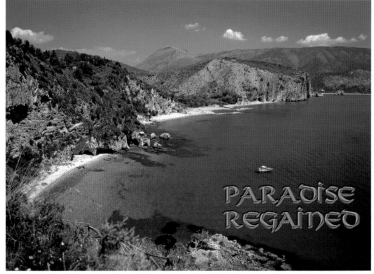

Making sure the text shows up clearly

Add words over an area of uniform color to show up the text better. You can bevel the text edges, shade it, or even lay it on a curve to get a professional-looking effect.

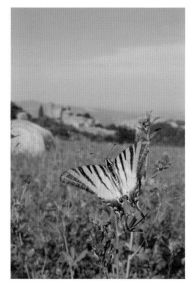

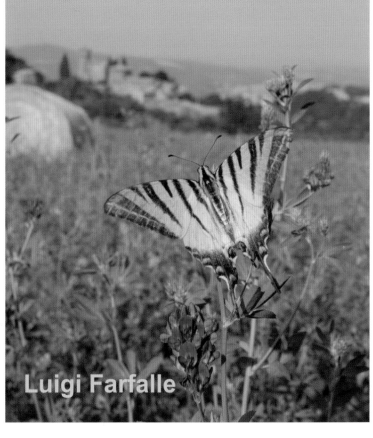

Leave space for the text

If you are shooting a picture for a book or magazine cover, or even for a home-produced brochure, make sure you leave enough space for a title—even if, pictorially, this sometimes means that the composition looks awkward.

83 How do I stitch a series of landscape pictures together to make a panorama?

In Question 52 (page 74) we looked at how to take a good set of pictures for a panorama. On screen what you have to do is take several overlapping images and fit them together so that the joins don't show. This is why you need a good set of images that all have a similar exposure and are on the same scale. You can work with several images in Photoshop or other programs, each in a different layer that you slide over the next. You will need a really big screen image so that you can see a row of identical pixels at the edges, and then align these one above the other. This is not an easy task, which is why designers have developed programs that do the searching for you electronically, and give a much better matchin the blink of an eye.

In Photoshop Elements, follow this routine:

Go to File > Photomerge and a browser appears—this is a window that contains your images in folders. Navigate to the folder that contains the pictures you want to use. Shift click on the images by holding down the shift key and clicking on each image, and then click Open. You can try to arrange things first and then let Photoshop take over to

The individual elements of the panorama
Below is the series of four images that I shot to make up my panoramic view.

smooth out the joins or click the check box Attempt to Automatically Arrange Source Images.

Now check the Apply Perspective box—start with 50% so that you get something that fits on the screen, and click OK. Photoshop Elements opens, positions, and generally tweaks the series of pictures to make a single image—it is incredibly ingenious.

The finished composite is displayed on the Photomerge screen. The preview window shows what it looks like before cropping and you can use the navigator with its red rectangle to travel over the whole image and enlarge sections to see how well it has worked.

Things are not finished yet. Go to Composition Settings, where you can flatten and blend the parts of the image with Cylindrical Mapping and Advanced Blending; this gets rid of the joins between different parts and matches brightness. The preview window lets you see the result. When you are happy, click OK.

Your stitched panorama in the Elements editing window will almost certainly need cropping to remove overlaps from the top and bottom of the image. Click Fit in Window to see the final result displayed, then save it.

Creating a panorama in Photoshop Elements
The Photomerge screen in Photoshop Elements displays the composite image, which you can then crop as you choose. By selecting Advanced Blending, you can also smooth out the joins between the different photos and ensure that the brightness is consistent across the whole panorama.

84 Now that I need to print my pictures, what is the best type of printer for me?

Features to look for:

Number of color cartridges: a separate black cartridge is preferable; four color cartridges is the minimum recommended for good quality. Check that the color cartridges are separate so that you can replace them individually.

Printer speed: often given as pages per minute (ppm). A good average speed is 20ppm.

Resolution: often given as a high figure, such as 2880dpi, but this equates to 200–300dpi, which gives a good quality.

Paper size: standard printers will output prints at a maximum of 8 x 10 inches. You will need a wide-format printer for prints up to 13 x 19 inches.

Direct printing: the ability to connect your camera or the memory card direct to the printer.

Ink type: check the type of inks used as standard. Most are dye based, which gives good, bright colors that are fade resistant for approximately 10 years. Pigment inks last much longer, but are considerably more expensive.

The range of printers can be confusing. Before you buy, think about all-round use, the maximum size that you want to print to, and your budget.

Inkjet printers are the most readily available and widely used, and a standard inkjet printer designed for text can do a reasonable job of printing photos, if it has the right paper options that allow it to get the correct amount of ink on the paper.

Photoprinters are also inkjets. They are slow with text but they give great results and the best easily rival traditional prints when used with coated papers. But beware of hidden costs: inkjet running costs are high. If you use the manufacturer's own inks at a premium price, the small ink tanks drain quickly; use cheaper inks and you invalidate the printer guarantee. Some of the better printers have continuous inking systems made for them and these are much more economical as you buy what you need and don't have to throw away a cartridge when the computer tells you, just because one color has run out.

Laser printers are more suited to printing text, which they do well at speed. Color laser printers are expensive and are not best suited to printing photos—the quality does not match that of an inkjet.

Dye-sublimation printers (dye subs) create great-looking prints—at a price. They do not print text and are currently only available with small print sizes, such as 4 x 6 inches up to 8 x 10 inches.

If you want to print standard-sized prints, such as 5 x 7 inches, and have the option of printing text, then a good-quality inkjet photoprinter will suit most needs and budgets.

Printer quality (opposite)
Natural history shots and close-ups, in particular, need to be pin sharp and full of detail and nowadays it is easy to produce high-quality prints at home. But although printers are relatively inexpensive, inks can cost a lot. The best option is to buy a printer on which you can replace individual colors as they run out.

Check your print colors (right)
Photos with strong colors and contrasts, such as this shot of trees in fall, are a good way of checking how effective your printer is.

85 How do I print to different-sized papers, or even put several pictures on one sheet of paper?

To print any document or picture, go to the File menu and work down to find at least two headings—Page Setup and Print. When you select one of these options, a window will open in which you can specify the paper size on which you want to print. To enlarge a print, or print on smaller paper, go to Page Setup, where you can select the size of the paper and whether your image is to be landscape or portrait format. You can also change the size of the image. When complete, go to Print and select the correct type of paper from a drop-down menu.

In Photoshop Elements, you can print several images on the same sheet of paper through Picture Package (File > Picture Package).A new window opens with options on the left-hand side. There are all sorts of preset layouts, depending on which paper size you select (Page Size). Directly below is Layout, which gives you options for different picture sizes and combinations You can make all the prints the same size or have some large and some small.

If you have a picture on screen already, then all the picture boxes will have this image. If you want different images on the same sheet, click on an image to replace; this brings up a new Select Image File window. Go through your image folders and files to find the image you want and then click to make it appear in the window.

Contact print
Even if you store all your digital files on disk it is very useful to print out a contact sheet of an image for easy reference. You can generate one automatically in Photoshop Elements via File > Contact Sheet II.

Several photos on one sheet
The picture package facility (File > Picture Package) lets you arrange a number of pictures on a single sheet from a list of options including two 5 x 7-inch prints, 9 or even 16 prints (useful for passport photos).

Different photos on the same sheet
To produce a print containing different pictures, set up the format you want from a single

picture and then click on any of the images to select a custom file to appear in that position.

Different sizes of photo on the same sheet
A particularly useful feature of Picture Pacakge is the fact that you can arrange different sizes of prints on a single sheet.

86 I can't get the printed colors to appear as they are on my monitor screen or on the camera LCD—can I change this?

It is possible to adjust the the monitor and the printer profiles so that your prints are more accurately color-matched. You will need to consider the calibration of your monitor, the color profiles of your printer, and also the type of paper that you are printing on. Macs have a built-in color matching facility. Many people use the ICC "color profiles" (supplied with the printer)—a set of computer instructions that match colors on camera, screen, and printer.

Some manipulation programs, such as Adobe Gamma supplied with Photoshop, allow you to calibrate the monitor screen first. Then try to balance the printer with this visually; the printer software lets you

Balance screen and printer
If your first prints are disappointing, you may need to balance computer screen and printer. Macs do this easily—but you can use a screen-calibration utility (Adobe Gamma) to help set things up. Choose a photo that contains a range of different colors, such as these store fronts, to use as a test.

adjust colors through its on-screen control panels.

The way you view the print and screen will differ—check that your screen is not set too bright and never work with direct light on the monitor. Are you going to view your prints in daylight or artificial light? The dyes will give slightly different results. Set things up in the conditions you will most often use.

If your print has a color cast you can try to correct this on screen—for a magenta cast, reduce magenta on screen or increase green, the complementary color (see Question 78, page 106). To make differences at the printer end you have to make quite big changes on the color sliders or try to adjust the printer through its control panels.

Sometimes problems arise when you use different papers, even those from the same manufacturer, that absorb inks differently and color casts (often magenta) are created. Test with some samples, decide what your stock paper will be, and then set things up as a default.

87 I want to make some large prints. What size files do I need to start with and how big can I go?

Shoot at maximum resolution
To make large detailed prints you need big files—so if you think you will want to make large prints, shoot at the maximum resolution your camera can provide. You can easily reduce file sizes if necessary, but you cannot create detail that is not there in the first place.

Specific programs for large prints
Professional photographers and others use Digital Fractals and similar programs for making huge prints. The image data is coded in such a way that you can make giant enlargements that retain tremendous detail.

The final size of your print will be ultimately determined by the size of your printer. But the resolution of the image and the number of pixels will also determine the sharpness of the final print. Many photographic magazines and books created a myth about the output needed to get a sharp print, specifying 300dpi. The truth is that using 180dpi on a good printer you would be pushed to tell the difference and what is more, the file sizes needed are much smaller.

The table below shows the camera sensor size in megapixels and the corresponding final print size that is possible.

PRINT SIZE REQUIRED	PRINT RESOLUTION	
	200 dpi	300 dpi
3 x 5 in.	1.72 MB	3.86 MB
4 x 6 in.	2.75 MB	6.18 MB
8 x 10 in.	9.16 MB	20.68 MB
8½ x 11 in.	11 MB	24.9 MB
11 x 17 in.	22.1 MB	49.7 MB

88 There are lots of different inkjet papers around and also some cards. The names are confusing, so what should I choose?

The best papers for printing your photos are coated papers with a layer that includes a type of clay so that inks do not blotch and smudge. The best quality generally comes from glossy photo papers, and so-called "Premium" papers often have a better resistance to fading. The list below details the different types of paper.

Look at the "weight" of the paper, which is given as gsm (grams per metre squared): the higher this is, the heavier and thicker (and more expensive) the paper will be. Some printers have difficulty feeding the heavier papers through. A good, standard paper weight is 255gsm.

Plain paper—good for test prints and for printing text.

Inkjet paper—a coated paper, good for draft-quality prints.

Photo paper—designed specifically for printing photos, has a bright white coating and is the best choice for most prints.

Glossy photo paper—an expensive option, but with professional results that gives the best color and sharpness close to that of a traditional film print.

Greetings-card paper—available in many different colors, finishes, and weights to suit your project. Make sure that it is suitable for your printer.

Gloss finish
A good paper will give realistic blues, reds, and greens and blacks that are crisp and not muddy. Gloss scores over matt finishes if you want the most "photorealistic" results.

top tip

Always print on the correct side of the paper; this is usually the glossy or shinier side.

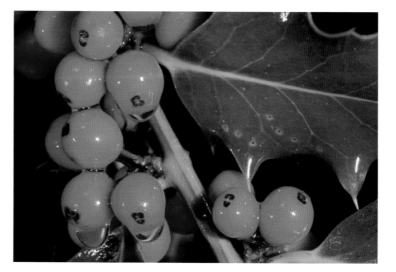

Check how a paper handles colors
A photo with a wide range of colors will let you see what a paper can do. Does it handle reds, green, and blues, well? Is the result sharp and bright?

Know your paper
When I printed this image on a new paper, the first prints of this picture showed curious pinks due to a strong magenta cast: rather than change the set-up, I reverted to a paper that I knew worked.

89 I have heard that inkjet prints fade. How do I prevent this from happening?

Ensuring longevity
With time, exposure ultraviolet rays affects dyes—even if the colors are strong to begin with, as in the shot above. If you display them, use a UV-resistant spray and then mount the print behind glass.

Inks versus dyes
Pigment inks keep their colors longer for than dyes but are not as subtle—not a problem if you want a really vibrant print.

Early prints made with inkjet printers faded horribly when exposed to sunlight, even at low levels. Ultraviolet (UV) was the main culprit but many prints faded even though they were in a closed drawer, simply because dyes were not stable. Things have improved with better papers and inks—but if you want your prints to last, then there are some steps to follow:

Inks—"archival" inks are more light fast. Generally, pigment inks (with tiny articles of pigment) last longer than dyes.

Papers—coated papers are produced that claim a longer print life. They are more expensive than basic photo papers, but if you are going to take the trouble to get something framed and hang it on the wall, then it is worth making sure it will last.

Varnishes—a varnish is a lacquer spray coating that adds a protective surface coat to the print and resists the UV light that causes fading. Following the manufacturer's instructions, spray in several passes vertically and then, after a few minutes' drying time, spray horizontally.

Storage—prints will resist fading if you keep them out of sunlight. If they will be on display, then use pigment inks together with a protective spray and put them in a frame with a glass cover.

90 How do I store images on my hard drive? How many can I fit on my hard drive?

When you connect your computer to the camera or a card reader, the images will be copied into a folder on your computer. Label the folder and store it on your hard drive. You can improve the organization of your filing system—and make finding images simpler—by setting your camera to give sequential numbering (through on-screen menus), so that one set of images begins its numbering from where the previous one ended. It does not matter what the numbers are, as long as they are different. If you use more than one camera, you can code each set of numbers so that you know which camera they came from. For tips on organizing your folders, see Question 94 (page 128).

If you take high-resolution images, then even a drive that you thought was huge when you bought it fills up at a frightening rate, for image files are large. You can add to your hard drive, but it is sometimes simpler, and safer, to download to CDs or DVDs as a storage option.

The number of images that you can store depends on the file format and size. TIFFS are lossless files, which do not lose data when compressed and therefore do not change size. JPEGs are "lossy" and compress to make smaller files, although there is some loss of data and quality.

Keep back-up files
Some people have a separate hard drive that becomes an archive. Never keep just one copy of a file: store two or more in different places for security.

		125 MB memory card	700 MB CD	4.7 GB DVD	40 GB Hard Drive	120 GB Hard Drive
	basic	142	770+	5000+	43,500+	131,600+
JPEG	normal	74	400+	2600+	22,800+	68,400+
	fine	37	200+	1300+	11400+	34,200+
TIFF		7	38	250+	2150+	6450+
RAW		12	656	430+	3700+	11,100+

The table shows the maximum number of digital files you could store without extra compression. The numbers are a guide to the size of hard drive or the number of DVDs or CDs that might be required to store a collection. In reality,, most people store files of different sizes.

91 Will I need much more computer memory when I start handling images?

top tip

Fit as much RAM (Random Access Memory) as you can. This is the part of the computer that handles image data and if it is not large enough things slow down a lot. Most imaging programs need at least 250Mb to handle large files and layers.

If you live in an area that has frequent storms, it makes sense to invest in an anti-surge device for the computer to protect precious memory chips and file storage.

File sizes
Files get bigger all the time – especially when you are shooting subjects such as the ones shown on these pages, in which you want to retain detail or have images that require a lot of imanipulation—and drives fill up quickly.

The truth is you can never have too much computer memory. There is, however, a distinction between the types of memory that you need: RAM (what the computer uses on its mother board for handling programs and calculations) and ROM—the hard drive, CF cards, and any ancillary hard drives, together with capacities of CDs or DVDs used for storage.

Get as much RAM as you can with your computer and then make sure that you can fit more in the future. As newer versions of programs appear, they become memory hungry and your work can slow down dramatically if the computer cannot draw on enough RAM and has to start sharing functions.

If you handle relatively small images (for example, up to 10MB), then you will not encounter problems but files can grow startlingly, especially where you have made changes in Photoshop and have "layers" that you need to preserve.

Storage is easy for you can, in theory, just add hard drives—either as external devices or as second and third internal drives if the computer has space. DVDs can be used to archive photos, since they hold 5 GB and more, which is at least 200 large files of 25MB each and a vast number of smaller files.

92 I want to make my own photo CDs and DVDs. Is this easy? Can I get prints made commercially directly from them?

When it comes to CDs and DVDs the "burning" process is getting easier all the time and this is a very cost-effective way of storing lots of picture files or of sending them away to be printed. CDs bought in bulk cost cents and are a great way of sending image files to friends and clients.

All computers that have a built-in CD or DVD writer come with the software needed to write the disks. One of the most versatile of all pieces of software for DVD and CD authoring on PCs and Macs alike is "Toast" from Adaptec. It allows you to copy CDs and DVDs (with due attention to the law regarding copyright and piracy, of course) and you can burn in "sessions" until the CD is full. When you open a disk on screen you get a number of disk images equal to the number of sessions. External CD and DVD drives are available if your computer does not have one built in.

When you have written your photos onto a CD, you can take them to the print shop where they can output the files onto paper, using not just inkjet prints but other techniques, such as dye sublimation, that look even closer to a traditional print. Before you write the CD, find out what format the print shop requires; as a rule, everybody can use JPEGs or TIFFs, and these are tried-and-tested formats for writing files.

Archiving pictures
I can't resist shooting sunsets: I burn new ones onto a "Sunsets" CD, using Roxio's Toast™—a program that lets you burn in separate "sessions."

The benefits of a large screen
Many DVD players allow you to view your photo-disks on a television screen, so that you appreciate the intricacy of subjects such as this passion flower on a much larger screen than the one on your computer.

93 Can I change a file into a different format, such as a JPEG to TIFF?

Photo-manipulation programs allow you to change file formats easily. Many people find that on a digital SLR the "fine" resolution JPEG gives a file of just over 2MB, which can then be opened as a TIFF of 17MB, and you would be hard pressed to see any difference between the much smaller JPEG and the TIFF.

To change a format, select Save As from the File menu on your computer and then select the option you want from the menu. Then the dialog box asks you to specify the file type, give it a name, and choose where you want to store it.

RAW format file
Serious photographers often shoot RAW format to keep all the original picture data: to use the picture, most people then convert the image to TIFF, manipulate as they want, and print. TIFF is the format generally used by publishers.

Fine JPEG
This picture was taken on a digital SLR as a fine JPEG (2.7MB) and opened to a 17MB Tiff. It was manipulated and stored as a TIFF. Compared with a picture shot directly as a TIFF, there is no difference.

94 I used to get in a mess with slides and photographs—how do I organize my digital files?

It essential to have an organized filing system and there are many programs available that will make life easier. Mac OSX has a superb filing tool in iPhoto; similarly, Windows XP on a PC has tracking tools so that you can browse, store, and even create slide shows of your pictures. Many relational databases (a database that can link different categories, or fields, together), such as Filemaker Pro, also handle images.

The important thing is to spend some time setting up your filing system at the beginning, so that you establish a routine when you download another batch of files from your camera. If you enjoy taking snapshots of friends, family, or vacations, then you can organize things by date, so that as you get a new set of pictures you download them into a new folder labeled with the date. As long as you remember what happened when, you can find the pictures. Alternatively, you could set up a series of folders for friends or places.

Portfolio
There are many file programs on the market. I use Portfolio because it lets me assemble sets of images to cut to CD or even put on the web. I can add search categories later.

Relational databases
File programs use what is called a relational database: the computer knows where the files are and it assembles "pages" that match your requirements. To locate this image, for example, I just typed in bees/pollination.

This is very much like having photo albums or boxes of pictures, and works when you have just a few pictures—but when the collection expands, you will need to rethink.

Many filing programs depend on setting up categories or "fields"—for example, plant name/color/ habitat/country, for garden shots. You label your picture in the database by filling in a box or boxes with details. You can then search for "keywords," such as orchids/purple/South America, and the program collects all the pictures together that satisfy these criteria and makes a page from it. Some programs even allow you to make these pages into web pages. The beauty of this is that you can add "fields" as your collection grows: simply add words to the label.

All these programs let you create a light box on screen where you can see your pictures arranged in all their glory and produce slide shows.

Devising categories

Accurate labeling is essential. With botanical subjects such as this orchid mantis, that entails labeling by both common and Latin name, and then by categories such as camouflage, predator, behavior, tropical insect, mantis.

95 Will my digital images last?

Preserving images for posterity (above)

If you record things that are getting rare or disappearing altogether, such as rare flowers, then your images need special care. Archive only on the best-quality CDs and DVDs. People once thought CDs were indestructible: they are not.

Preserving prints (below)

Precious times in young lives are things you will want to keep for ever. Make your prints on high-quality paper and store them out of light in files or albums.

Re-recording on new media (right)

This tree image was an early digital picture: it was initially stored on a ZIP disk, then burned to CD, and is now archived on DVD. As media change, you will find that you need to re-record images in order to be able to access them.

Color prints fade after some years, as do color slides; black-and-white prints lasts longer, but whenever they are exposed to light, fading is inevitable. Museums and galleries do all sort of things, such as using acid-free papers, to prolong the life of prints. We want to feel that digital pictures will have the same longevity, if not better. One approach is to make prints, and to use papers and inks that will give a long life (see Question 89, page 122).

But what of the digital files themselves? We all know how computers advance and storage media change, with the result that we accumulate piles of disks but are then left without a means of reading them. To allow for changes, factor in the idea of copying old files on to new media every few years. You also need to consider that files can become corrupted—magnetic fields affect storage media and CDs do not have the unlimited life and indestructibility that was part of the hype surrounding their launch.

CDs and DVDs are the only cost-effective way of storing the thousands of picture files you will surely amass. Buy the best you can afford that have a long life. Cheap CDs are a risk and your files precious.

Always store CDs and DVDs in jeweled cases and keep them away from bright lights, damp, and extremes of heat and cold. Manufacturers produce estimates from tests that simulate real life conditions for a few decades, but in reality we simply do not know how long these things will last. But we can do the best we can by taking care of them.

96 What do I need to view my pictures on a television set?

PDF slide show
Photoshop Elements allows you to replay a DVD on your television from any picture collection. Just go to File >Automation > PDF slide show. You can set the delays or provide a repeat loop when using as a display for advertising or marketing purposes.

Many digital cameras come with a lead that lets you connect them directly to a television through its aerial socket, and then view the contents of the camera's memory card on a large screen. You can also purchase stand-alone units that have an outlet to connect to a television—download onto the stand-alone unit, and then transfer the files to the television. Alternatively, you can purchase card readers that fit into a slot on your computer, that then outputs to the television.

Many households now have a home DVD player that lets you play PhotoCDs and DVDs with pictures, and this is a great way of looking at your pictures on screen. Check the instructions to see what size files you need to cover the screen. You can zoom in on smaller pictures or zoom out with larger ones, using the hand control for the DVD player.

97 How do I create a slide show?

Using your DVD player to view a series of pictures and click from one to the next on the handset is one way of showing your photographs to friends and family. However, you can improve on this by using the Slide Show option that is available on many imaging programs. Assemble the pictures you want in the order you want by dragging the files from a folder to a list on your computer. You can then decide how much time you want a picture to be displayed.

More sophisticated options let you create titles that you can intersperse and allow effects such as dissolves from one picture to the next. If you take a whole series of pictures on vacation, then you can put them in sequence and even add your own commentary or music. Cut this to CD or DVD and you have a record for future years—and a great way of sharing memories with family and friends.

98 Can I project my digital pictures as I did with 35mm slides?

A digital projector can project an image of your monitor screen for display or for lecture purposes. There are programs, such as Microsoft's "Powerpoint," which help to put the show together. The price of a good digital projector puts them out of reach of most ordinary users, but many educational institutions or hotels with conferencing facilities own them, and even many camera clubs, so you may get the opportunity to use one.

The image on a monitor screen is viewed at 72 dpi, which breaks up badly when projected, so you will have to sit some distance away to view the image. To avoid this, save your material on CD as a file of JPEGS or TIFFS, so that it can be inputted into the computer. If you lecture regularly, then take your own laptop and don't rely on in-house equipment—just adjusting contrast, brightness, and color for the projector makes a whole difference.

If you do purchase a digital projector it can be used to project DVDs and create a home cinema or, for Mac users with iTunes, the most incredible light shows synchronized to music through the "Visualizer."

Digital projection
The same slide show that you create for television can be viewed by a bigger audience if you output to a digital projector. You can create a full-blown show with music fades , effects and titles using a standard program such as Microsoft Powerpoint.

99 *I want to e-mail pictures to my friends. What is the best way to do it?*

Share your experiences
Sending pictures by e-mail is a great a way of keeping in touch with friends and family members when you are traveling. Pictures can be attached to any regular e-mail program via the Attachments menu. Never send huge files that tie up the recipient's computer.

E-mail was designed to send and receive text, but you can also send pictures as "attachments" using an e-mail program. When you create an e-mail attachment the words "encoding attachment" flash up on screen; your computer is coding the picture information so that it looks to the e-mail servers as if it is text—albeit a very long message.

Put the pictures you want to send into a folder or on the desktop where you know where to find them. Write your e-mail as usual and look for the Add attachments option (with a small paperclip icon). Clicking this brings up a browser that lets you find the pictures. Click on the titles to add them and you will see their names appear in the menus bar of your e-mail. Click Send.

If you have a fast telephone line, such as ISDN or ADSL, then there are no problems sending large files—but you may encounter problems when sending large files on an ordinary telephone line with a 56Kbps modem. If the recipient has restrictions on the size of his or her mailbox you can choke it, and give them the inconvenience of going on line, accessing their mail through the provider, and deleting things to make room. Or it may just be bounced back to you. Keep files small and attach only a few at a time. A 6 x 4-inch picture, saved as a medium JPEG at 72dpi, is about 124KB. Send one to yourself and see how long it takes to download.

top tip

When you send files to view on screen, they need only be 72 dpi (screen resolution). You can make them look better by applying Unsharp Mask at 80% and no more, with the radius set at 1.5, and threshold at 8 or more (see Question 79, page 107).

100 How can I put my pictures in a newsletter or brochure?

Producing books and leaflets (above and below)

Book and leaflet production was once quite literally a matter of "cutting and pasting." Now the whole thing is handled by computer from the file that you create on your camera and, with a little practice, anyone can produce professional-looking material. Two useful tips that it's well worth bearing in mind are not to be afraid of leaving space and (however tempting it might be when you have lots of different fonts at your disposal) not to use too many different typefaces in one document.

Desk-top publishing (DTP) has put the production of professional-looking materials such as brochures, newsletters, and even books, into our hands. You can create brochures and leaflets at home, and then cut the material onto CD and take it to a professional printer to create the finished product.

DTP programs are the electronic version of a sheet of paper upon which you place boxes of text and pictures, and arrange them to produce a design. There are numerous DTP packages, from the top-end professional systems such as Quark and Adobe In-design through to Microsoft Publisher for PCs and Apple Works for Macs, to word-processing packages that let you handle pictures.

In whatever package you have, there are several kinds of boxes—those designed to handle text and those for pictures. Many people prepare their text in a word-processing package such as Microsoft Word, and then copy and paste it into the text box. You create picture boxes and then fill them by clicking on the box and using a menu that says Get Picture—this takes you to your files to select the image you want.

Most DTP packages then import the picture and you can resize it by dragging one of the handles on the corners while you hold down Shift. This reduces height and breadth to the same scale. You can move the picture in its box to create the frame you want and then move the box. The more advanced programs let text flow around your pictures so that the leaflet looks professional.

101 How do I resize an image if I want to import it into a DTP program?

Some DTP programs allow you to reduce the size of the image after you import it into its box on your layout. But you can work on the picture first to "resize" it. Go to Image and then Image Size, where you see a set of boxes and options. In Document Size, you can set the height and width; to avoid a lot of problems, link these so that changing one changes the other to maintain the proper proportions. Check the Constrain Dimension box to lock the height and width.

It is best to decide on a fixed height or width for your layout box, adjust the picture, and then crop it if necessary. You can also maintain the resolution of your original image in this dialog box.

Dragging and resizing pictures (left)
This picture of flower seedheads was a part of a larger picture moved within a "box" on screen that acted like a frame to give the part I wanted.

Preparing for print (below)
This old jetty was printed for a book at a resolution of 300 dpi.

Working with a DTP program (right)
I adjusted the picture to fit from within the DTP package without going back to the picture file.

102 What do I need to do to put pictures on the web and how do I cut upload/download time?

Preparing batches
If you have lots of images to resize, Photoshop lets you automate tasks. This shot of butterfly wing scales was one of a set.

It is frustrating when pictures take a long time to upload to a site or for web pages to download and appear on your screen. You need to create picture files that are small enough to transfer quickly and yet look bright and detailed on screen—a process known as "optimizing." Most computers have small- to medium-sized screens—typically 15 inches—so images are sized to fit into an on-screen browser window. 640 x 480 pixels is typically the size of image you can use with the 3:2 aspect ratio that began with 35mm film.

A web page is not just one big picture file filling the screen but many different files displayed simultaneously, with each item precisely arranged using HTML (Hyper Text Mark-up Language). Many programs now provide you with a template for displaying pictures on a web page, so you can avoid the HTML bit. Although you can make a web page as big as you like, it is usual to go for 640 x 480 pixels and then to make links to extra pages. Images are generally compressed either as JPEGs (for pictures) or GIFs (for graphics); both are "lossy," which means that data is lost when the file is first compressed.

Web gallery
This ready-made option allows you to view all pictures together on a background of "parchment." The neutral color goes with most pictures.

Displaying a single image
A single picture can be featured on a larger canvas by clicking on individual images to display them in turn.

jargon buster

Aspect ratio is the length of the longer side of the frame compared with the shorter side. For example, 600 x 400 pixels is described as 3:2, and many standard picture sizes are based on these proportions.

Images for web displays
For web displays I use 600 x 400 pixel images resized and then sharpened slightly (Unsharp mask at 80%; radius 1.5; threshold 80%).

To get pictures ready for web use there are features in Photoshop Elements and many other programs that do the optimizing for you. For example, start with a high-resolution 300dpi file that you've used for printing. The first step is to scale it down to the screen resolutions of 72dpi and watch the file size plummet. Now go to File > Save for Web, where you get a preview of what your file will look like before compression starts. A grid appears with up to four versions of your file, each subjected to a different compression routine. For photos you will usually use JPEG with high- or medium-quality settings, with the "optimization" checked. Make your choice, click on the image, and press OK. You can rename the file or save it with its own web page for later use. If you click the browser icon in the bottom left of the window, you can see how it will look on screen.

Index of questions

From camera to computer

69. Can I use and store digital images if I don't have a computer?

70. How do I connect my digital camera to my PC or Mac?

71. What type or size of media card can I use?

72. Is there any advantage to using card readers compared with just plugging in my camera to a computer?

73. How do I decide which image manipulation program to buy?

74. How do I get an image into the program and up on screen?

75. The image is on screen in front of me. How do I resize or crop it?

76. When the image is too dark or too light on screen, how do I change this?

77. My pictures lack contrast. How can I give them more punch?

78. Some images seem to have a color cast. Is it possible to remove or change it?

79. Can I rescue an image that is out of focus?

80. Can I remove people, telephone wires, and anything I don't want—or even add things to an image from another image?

81. If I don't like the sky or background in a shot, can I change it without it looking obvious?

82. How do I add text to the picture and make a card?

83. How do I stitch a series of landscape pictures together to make a panorama?

84. Now that I need to print my pictures, what is the best type of printer for me?

85. How do I print to different-sized papers, or even put several pictures on one sheet of paper?

86. I can't get the printed colors to appear as they are on my monitor screen or on the camera LCD—can I change this?

87. I want to make some large prints. What size files do I need to start with and how big can I go?

88. There are lots of different inkjet papers around and also some cards. The names are confusing, so what should I choose?

89. I have heard that inkjet prints fade. How do I prevent this from happening?

90. How do I store images on my hard drive? How many can I fit on my hard drive?

91. Will I need much more computer memory when I start handling images?

92. I want to make my own photo CDs and DVDs. Is this easy? Can I get prints made commercially from them?

93. Can I change a file into a different format, such as a JPEG to TIFF?

94. I used to get in a mess with slides and photographs—how do I organize my digital files?

95. Will my digital images last?

96. What do I need to view my pictures on a television set?

97. How do I create a slide show?

98. Can I project my digital pictures as I did with 35mm slides?

99. I want to e-mail pictures to my friends. What is the best way to do it?

100. How can I put my pictures in a newsletter or brochure?

101. How do I resize an image if I want to import it into a DTP program?

102. What do I need to do to put pictures on the web and how do I cut upload/download time?

Index

A

angle of view 22
aperture 11, 53
aspect ratio 139

B

batteries 34, 89
Bayer pattern 11
black-and-white photos 70
blemishes 108
blur 30, 53, 54, 58, 71, 107
buffer 57
Bulb setting 86
burst rate 57, 59

C

camera care 91–93
camera modes 18
camera shake 30
card readers 99
CDs 126, 130
close-ups 71–72
color cast 106
contrast 105
cropping 103

D

depth of field 54
digital zoom 23
dpi 118, 134
DVDs 126, 130

E

e-mail 134
exposure lock 76
exposure 11, 49–51, 75, 104

F

file formats 15, 43, 123, 127
file size 44
filters 32
FireWire 97
fireworks 86
flash 28–29, 34, 82, 85
focal length 24–25
focus 74, 107

H

highlights 21
hue 106

I

image manipulation 100–109
image size 44
interpolation 11
ISO 17

L

LCD 42, 49
lenses 24, 26
light 17, 76–77, 79–80
lightness 106

M

media cards 16, 98–99
megapixels 13
memory cards (see media cards)
memory, computer 123–124
metering modes 20
Micro-drives 98

N

night shots 84
noise 33